INDUSTRIAL STEAM IN BRITAIN

STEPHEN HEGINBOTHAM

AMBERLEY

This book is dedicated to absent friends, and all those touched by Covid-19.

I normally donate a percentage of my book royalties to charity, but because this book was compiled during the coronavirus pandemic, I will donate more of my royalties to charity.

First published 2022

Amberley Publishing
The Hill, Stroud
Gloucestershire, GL5 4EP

www.amberley-books.com

Copyright © Stephen Heginbotham, 2022

The right of Stephen Heginbotham to be identified as the Author of this work has been asserted in accordance with the Copyrights, Designs and Patents Act 1988.

ISBN 978 1 4456 9038 4 (print)
ISBN 978 1 4456 9039 1 (ebook)

British Library Cataloguing in Publication Data.
A catalogue record for this book is available from the British Library.

Typesetting by SJmagic DESIGN SERVICES, India.
Printed in the UK.

Contents

Introduction

I was born and raised in Stockport, and spent several years living in Edgeley, less than a mile from 9B shed and a mere stone's throw from 9C at Heaton Mersey. I can well remember those halcyon days, when steam and first-generation diesels were prolific, yet the running down of the old order was well under way – even though industrial steam was to survive longer than steam power on the national network.

While watching and recording passenger trains and locomotives, working away in the background were those unsung industrial locomotives keeping British industry going. I saw many of them, including those operating on the vast network of the Manchester Ship Canal Company, the operations around Trafford Park Industrial Estate, and very occasionally those that operated from the Cravens Works, where they crossed Greg Street in Reddish, Stockport.

Not possessing a camera until long after those days, I did not record any of those locomotives, but fortunately others did and these photographs have now been digitally restored by myself.

Information about industrial steam is not as readily available as that of the national network, and the records are sometimes sparse in detail, so please forgive me for those entries that are lacking in substance; it was not for want of research. In fact, I spent longer compiling this book that any previous book.

One interesting note about industrial steam is that without the massive influx of former Austerity 0-6-0ST from the Ministry of Defence from the 1940s to the 1960s, many much-older locos would probably have given way to diesel locos, or they would have had to soldier on far beyond their usual life expectancy. It is this huge addition to the industrial steam fleets around the UK, and from those stored after the Second World War, that the current preservation movement have drawn many of their smaller locomotives from. Nearly every preserved railway has, or had, an Austerity or other industrial locomotive at one time or another. The Hunslet 0-6-0ST Austerity class numbered almost 500 engines, and not only was it a large class numerically, but they were also the most common in private use.

I have learned much about industrial steam during the fascinating research into this book, particularly the Austerity 0-6-0ST class, which has been an insight into how simple designs and quick construction do not necessarily mean poor build quality or short life.

Industrial Steam

If it had not been for the hundreds of locomotives in use within the former industrial complexes that at one time seemed to populate almost every corner of Great Britain, and which manufactured a multitude of products for use at home and abroad, including the numerous service industries, the burgeoning railway preservation movement would not be where it is today.

It was not just heavy industry or general manufacturing that used them. There were many service industries, such as the Manchester Ship Canal; various gas boards; breweries; power stations; coal mines including the National Coal Board (NCB); and quarries that used these steam, and later diesel, locomotives.

Almost all of the heritage railways that are in existence today started with a redundant but functioning former industrial steam or diesel locomotive. As industry no longer found the need for their workhorses, or had decided to switch to diesel-powered traction, hundreds of these rugged, simple machines were withdrawn. Some were surplus or too costly to maintain; others were just too labour-intensive.

Great Britain was once the industrial leader of the world, and many of the industrial locos built in the UK were destined for use around the world. The army, in particular, had many such engines in use at their numerous military sites and many of these have also survived and are used daily on heritage railways.

Although many industries continued to use steam long after British Railways had abandoned it in August 1968, eventually even they had to look to a cheaper, cleaner and more efficient way of moving their products around their industrial sites.

When the hundreds of industrial engines were made redundant in the UK, the businesses either stored them or sold them off, usually relatively cheaply, and thus provided an inexpensive way of getting a new preservation project off the ground. Most of these former industrial locos are still with us and are used today, and as the years have passed they have become almost as valuable as some of their contemporaries from the national network.

With the BR ban on steam, the only way we enthusiasts could get our fix of steam was to visit one of the burgeoning preserved railways that were slowly springing up. Little did we know that once again, in future decades, we could enjoy the sight, sound and smell of industrial steam, albeit in a different setting. Industrial steam also encompasses the many stationary engines providing power to drive various pieces of equipment or machinery.

Nothing can replace a working, functioning railway, and while the preserved locomotives are beautiful to look at and smell the same and sound the same, they are cherished and nurtured in a way never thought possible fifty or more years ago. It is of

course understandable that they are looked after so well; they are now a very expensive and valuable asset and worth far more than anyone could have ever imagined.

I hope this book brings back a few memories for those that remember it as it was, and that it gives some idea of just how good it was when steam was the norm in Great Britain. Please remember that these industrial locomotives have been the saviour of many heritage railways we all enjoy today.

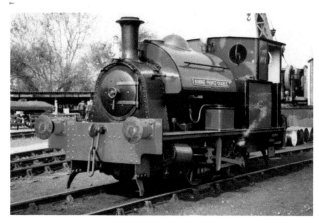

RSH 0-4-0ST *Bonnie Prince Charlie* was built in 1949 as No. 7544 for work at Poole Wharf and later at Corralls Depot, Southampton. In preservation, it is kept at the Didcot Railway Centre, where it is seen here in 1982. (Author's collection)

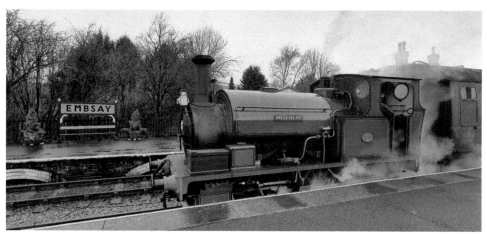

Hudswell Clarke 0-6-0ST *Mitchell* (*Illingworth*) stands at Embsay station on the E&BASR on 2 February 2020. It was built by Hudswell Clarke in 1916 for the Ministry of Munitions at Gretna Green and subsequently purchased by Bradford Corporation in 1922 to work passenger and goods trains on the Nidd Valley Light Railway between Pateley Bridge and Lofthouse and up to the reservoir site at Scar House. In 1930 it was renamed from *Mitchell* to *Illingworth*. When the Nidd Valley Light Railway closed in 1936 it was purchased by Sir Robert McAlpine Ltd and renamed *Harold*. It worked at the Ebbw Vale Steelworks until 1940 and was then sold to Mowlem where it was employed on war duties at Swynnerton and Ruddington, carrying the name *Swynnerton*. In 1945 it worked on the Workington breakwater and then Mowlem's Braehead Power Station before being consigned for scrap in 1957. It survived intact under several owners until discovered in a Norfolk garden by the current owner (Stephen Middleton) who restored it, and finally steamed again on the E&BASR in May 2017. In May 2020 it was announced that the locomotive would be renamed *Nightingale and Seacole* to show support for the front-line workers fighting the Covid-19 pandemic. (Richard Jones)

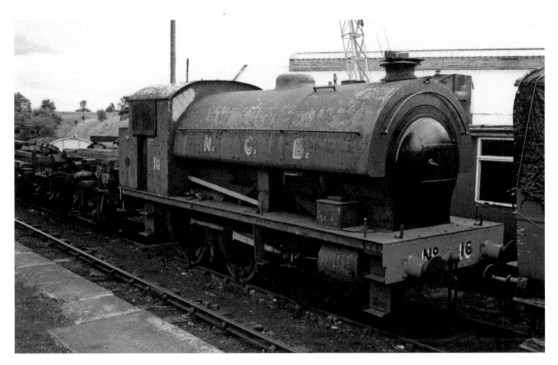

RSH 0-6-0ST No. 7944 was built in 1959 for the NCB (as No. 48), becoming No. 16 in 1971. Sold into preservation to the Stephenson Locomotive Trust in 1976, it moved to its current home of the Tanfield Railway in 1980. For a while, it was registered to operate over parts of the BR network. Seen here at Tanfield *c.* 1982. (Author's collection)

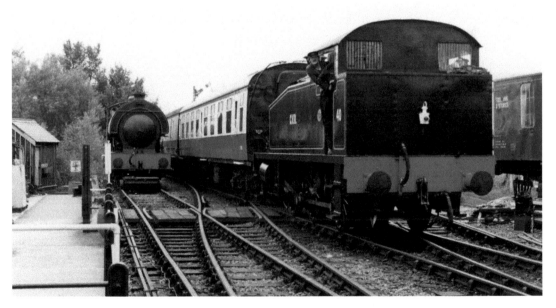

Another RSH 0-6-0T loco. Built in 1954 for the NCB as works No. 7765, it became No. 40 and was used for transporting miners around collieries. Sold into preservation in 1974, it is now being overhauled on the Weardale Railway. (Author's collection)

The RSH loco was built as No. 7845 in 1955 for the British Electricity Authority (BEA) as their No. 12. Last shown as on display at the Dales Countryside Museum, Hawes. (Author's collection)

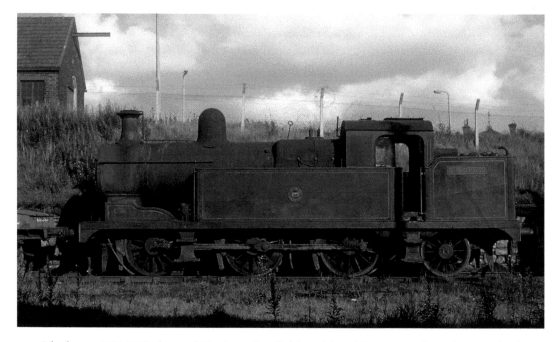

The former NSR *Sir Robert* and No. 2 saga is still debated, but this appears to be a photograph of the original loco built in 1923, and after dismantling and rebuilding in 1964/5 took the identity of *Sir Robert*. Withdrawn in October 1967, it was sold into preservation *c.* September 1968, but not removed. It was scrapped on-site by Maudland Metals in 1969. (A. Darby collection)

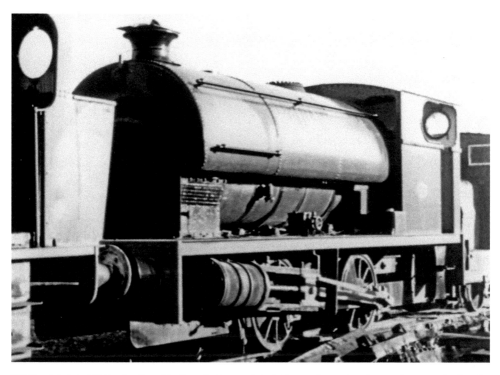

Whilst this 0-4-0ST is plainly of Peckett & Sons origin (OY1 or OY1-S) and was photographed at the Embsay & Bolton Abbey Steam Railway in 1977, extensive research has not revealed any information on it – including whether or not it still exists. (Euan Mackintosh – Maurice Dart collection)

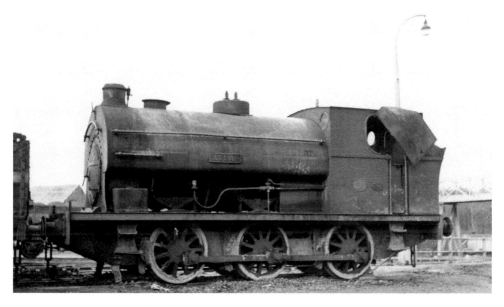

This 0-6-0ST is named *Atlas*, after Peckett & Sons' Atlas works in Bristol, where it was built in 1909 as works No. 1177. It is seen at Walkden Central Works along with others of the Austerity class (including a Giesl ejector example) and all appear in withdrawn condition *c.* 1966. It was scrapped on-site in September 1968. (A. Darby collection)

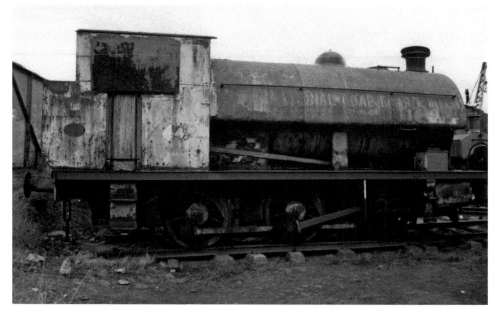

Built in 1954 by RSH as No. 7760 for the NCB. New to the locomotive depot at Backworth, Northumberland, it became No 44. Like many industrial locomotives it had to work over BR lines and was registered with the British Transport Commission, which meant that it was regularly inspected by BR. Now at the Tanfield Railway awaiting overhaul. (Author's collection)

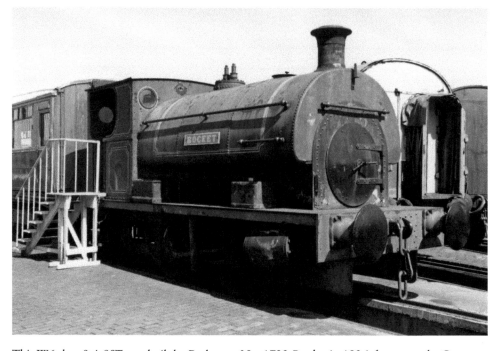

This W6 class 0-4-0ST was built by Peckett as No. 1722 *Rocket* in 1926, for use at the Coventry factory of Courtaulds Ltd. Sold into preservation, it ended up at the Telford Steam Railway. Seen here in 1985 out of use at Tyseley. (Author's collection)

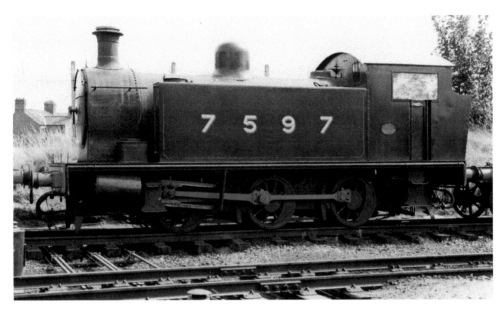

This 0-6-0T loco was built by RSH as No. 7597 in 1949 for the British Electricity Authority, and after it was withdrawn in 1971 it was preserved and restored, but resided at several heritage railway locations over the following decades including a spell at the Bodmin & Wenford Railway in Cornwall and is now at the Lincolnshire Wolds Railway undergoing a full overhaul. Seen here out of use at the GCR, Loughborough in August 1985. (Author's collection)

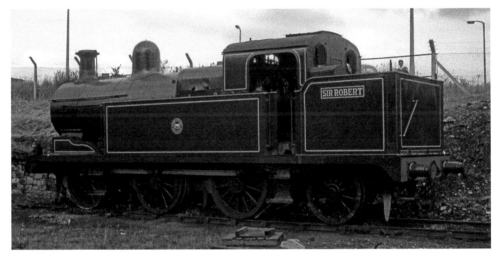

This North Stafford Railway-liveried L class 0-6-2T had quite an eventful life. Originally built as NSR 2 (LMS 2271), it was one of the last four engines built for the NSR at Stoke Works in 1923. In 1936–37, NSR 2 was one of the five locomotives sold to Manchester Collieries Ltd and worked at Walkden, where it received the name *Princess*. In 1964 the boiler, tanks and cab from *Princess* were fitted onto the chassis of another former NSR New L loco (NSR 72, built in 1920, which became LMS 2262). The NSR 2 identity was kept, and when withdrawn at Walkden the locomotive passed into the National Collection. In April 2016 the National Railway Museum gifted the locomotive to the Foxfield Railway, who have stated that after moving it to its Blythe Bridge facility in 2016, it is being assessed with a view to returning it to steam again. (A. Darby collection)

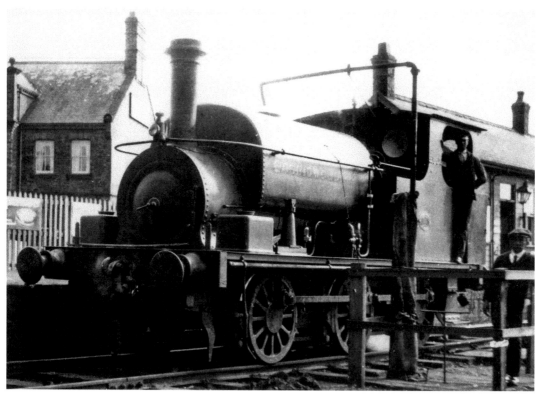

Easingwold Railway 0-6-0ST No. 2, built by Hudswell Clarke in 1902, shown here at Easingwold on an unknown date. It is presumed to have since been scrapped. (Maurice Dart collection)

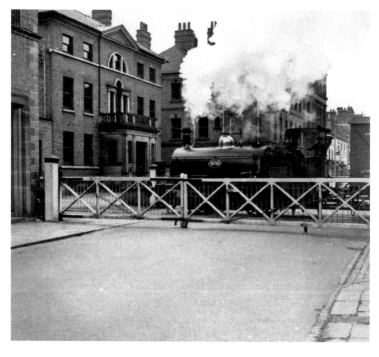

The location is the level crossing in High Street, Burton upon Trent on 17 September 1958 and seen here is Worthington's Brewery 0-4-0ST No. 6, which was built by Hudswell Clarke in 1920 as No. 1417. The Loco appears to have not survived. (Maurice Dart/ Transport Treasury)

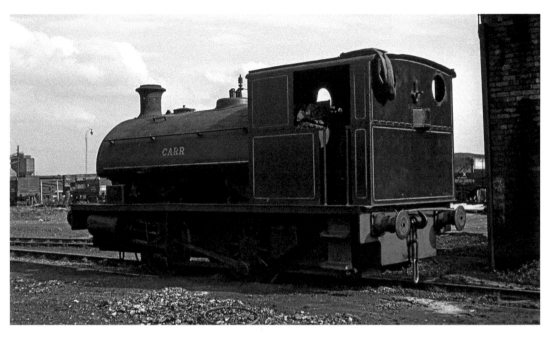

Hudswell Clarke 0-4-0ST *Carr* was built for the NCB in 1948 as No. 1812 and served at William Pit in Cumbria after August 1965, but is seen here *c.* 1964 at Walkden. (A. Darby collection)

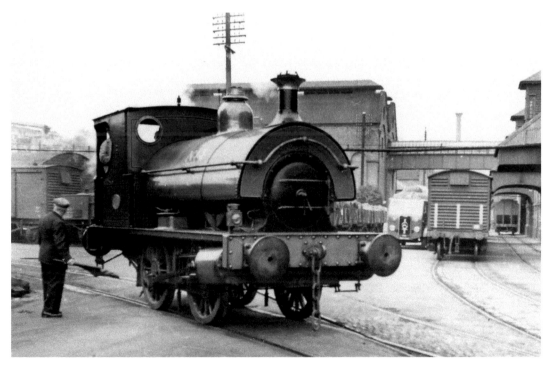

Guild Street Yard in Burton upon Trent on 17 September 1958 and we see Bass 0-4-0ST No. 3, built by Thornhill & Wareham in 1890/1 as their build No. 609. There is no record of it surviving. (Maurice Dart/Transport Treasury)

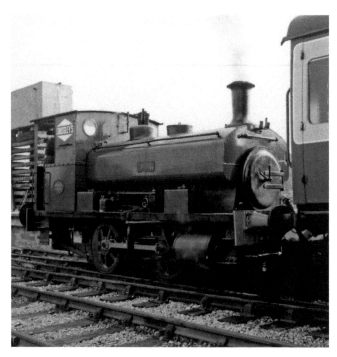

Andrew Barclay 1924-built
0-4-0ST No. 1823 *Harry/
Henry* at Peak Rail in Buxton
on 24 October 1987. Delivered
new to Colzium Quarry Co. Ltd
in 1929, it was sold to Yorkshire
Tar Distillers for use at their
Kilnhurst Works in Rotherham.
In the 1960s it moved to the tar
distilleries at Cleckheaton but
later returned to its original base
before being withdrawn from
service in 1972. The locomotive
started its life in preservation
at the Embsay & Bolton Abbey
Steam Railway, and subsequently
other heritage railways. Last
shown as on the Pontypool &
Blaenavon Railway, but thence
sold and moved to an unknown
location. (Maurice Dart)

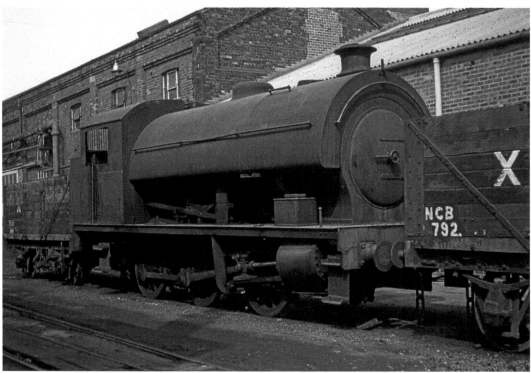

This loco is outside Walkden Central Works *c.* 1964 and is obviously withdrawn. Which
loco it is remains debatable, but from research it is a Hawthorn Leslie-built product, possibly
No. 2127 *Failsworth* of 1907. (A. Darby collection)

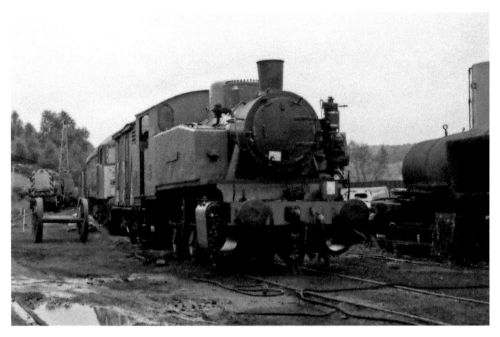

This former Polish loco, No. 2944 of 1952, was employed in industrial use around iron and steel works in Poland before being brought over to the UK. Now named *Hotspur*, it resides at Cheddleton on the Churnet Valley Railway in Staffordshire and is seen here on 21 August 2017. (Maurice Dart)

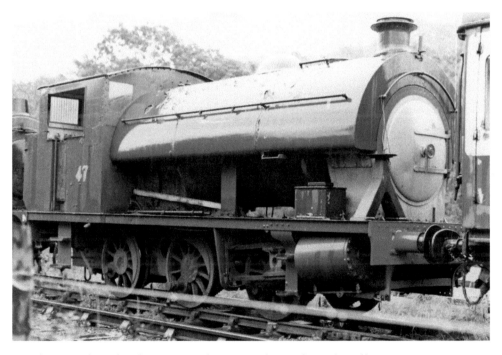

Another RSH loco for the NCB. Built in 1955 for Backworth Colliery as No. 7849 (NCB 47 *Moorbarrow*), it has since resided at several heritage railways, and is currently at the Gwili Railway. Seen here in 1987 at Grosmont on NYMR. (Author's collection)

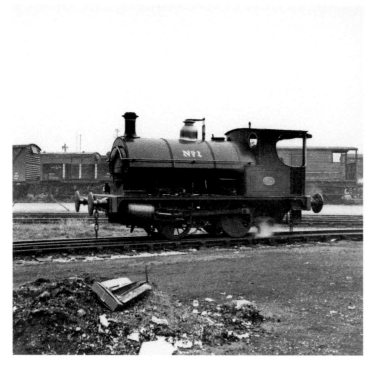

Seen here at Shobnall Sidings, Burton upon Trent on 16 September 1958 is 0-4-0ST No. 1, belonging to Bass Brewery. Built in 1900 as works No. 5759 by Neilson, Reid & Co. of Glasgow, it does not appear to have survived. (Maurice Dart/Transport Treasury)

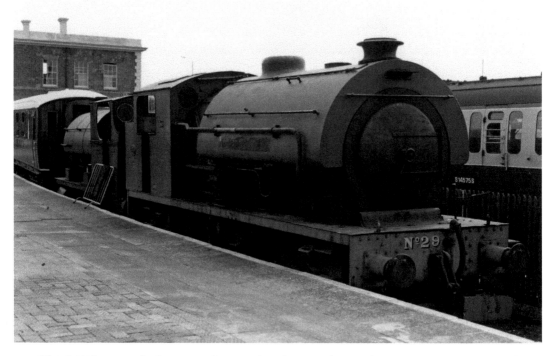

This RSH loco was built in 1950 for a steelworks in Corby. Works No. 7667 became 56 and was withdrawn in 1969 and sold into preservation. Seen here at North Woolwich Old station in 1988, it now resides at the Great Central Railway (GCR), Nottingham. (Author's collection)

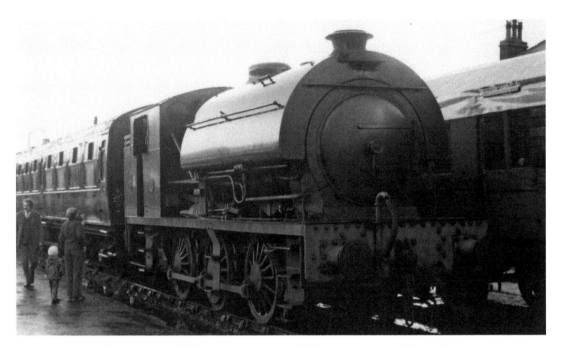

Another of the Corby Steel Works batch of 0-6-0ST is seen here in 1974 at Howarth on the KWVR. Built in 1950 as No. 7673, it became Stewart & Lloyd No. 62 *Ugly* and was sold into preservation in 1969, residing at various locations until ending up at the Spa Valley Railway. (Author's collection)

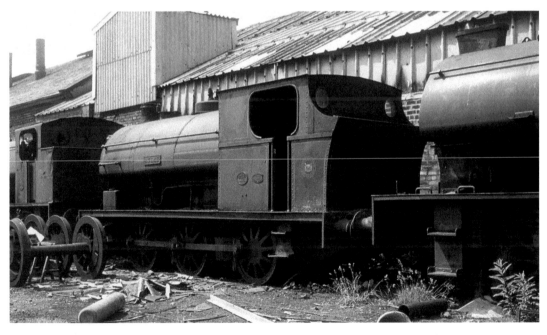

Atlas is seen here at Walkden Central Works along with others of the Austerity class (including a Giesl ejector example). All appear in withdrawn condition *c.* 1966. It was scrapped on-site in September 1968. (A. Darby collection)

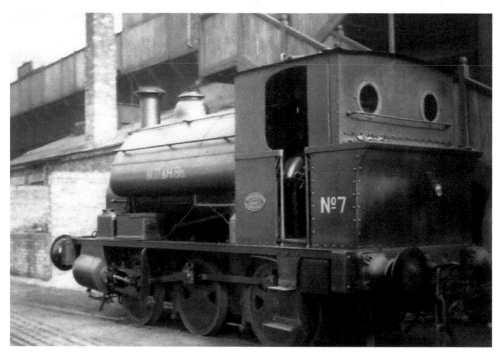

Former Mersey Docks & Harbour Board No. 7 is an 0-6-0ST built by Avonside Engine Co. as works number 1523 in 1907. Seen here at 24 Dock, Liverpool awaiting repair on 25 October 1947, with the Liverpool Overhead Railway in the background. It is not thought to have survived into preservation. (Ken Brown/Maurice Dart collection)

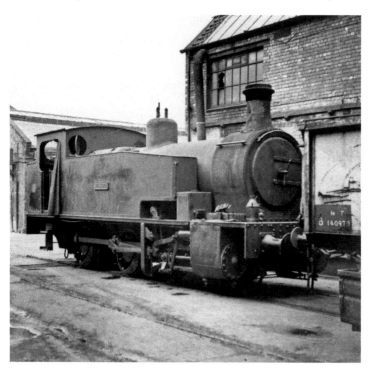

This picture was taken in the NCB Walkden Yard on 27 October 1957 and depicts Hunslet Engine Company 1924-built 0-6-0T loco *Joseph*, works No. 1456, not thought to still be in existence. (Maurice Dart/Transport Treasury)

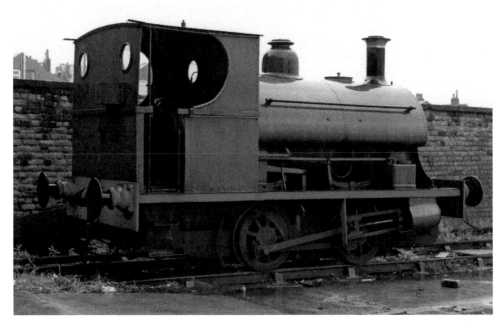

Peckett & Sons built this 0-4-0ST No. 1163 *Whitehead* in 1908 for a South Wales colliery. Sold in 1966, it now resides at the MRC at Butterley, but is seen here in 1988 at Steamport, Southport. (Author's collection)

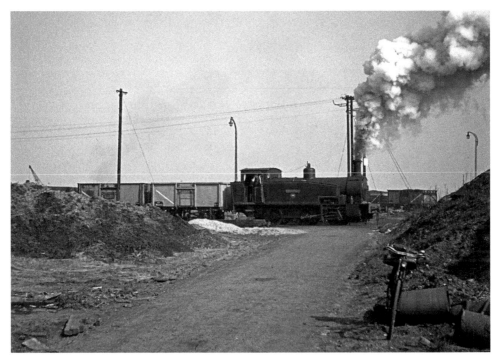

Shunting at Astley Green Colliery *c.* 1967 is Hunslet 0-6-0T *Bridgewater*, which was built in 1924 as No. 1475 and scrapped on-site in October 1968. (A. Darby collection)

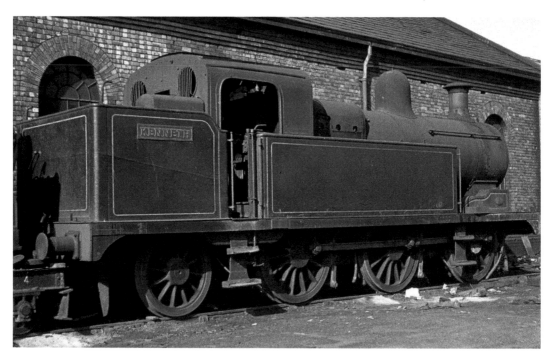

Kenneth is a former North Stafford Railway 0-6-2T built in the Stoke Works in 1921 and sold to the Manchester Collieries in June 1936. Seen here withdrawn at Walkden Central Works, it was stored from October 1961 to April 1967, when it was scrapped on-site. (A. Darby collection)

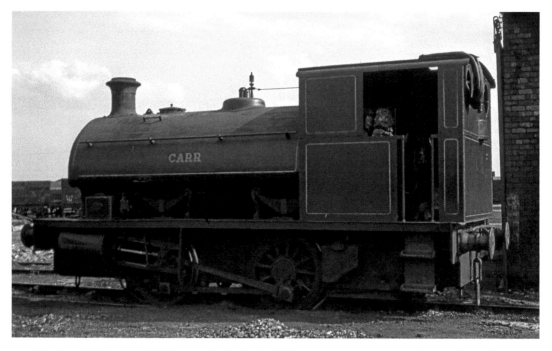

Hudswell Clarke 0-4-0ST *Carr* was built for the NCB in 1948 as No. 1812 and served at William Pit in Cumbria after August 1965, but is seen here *c.* 1964 at Walkden. (A. Darby collection)

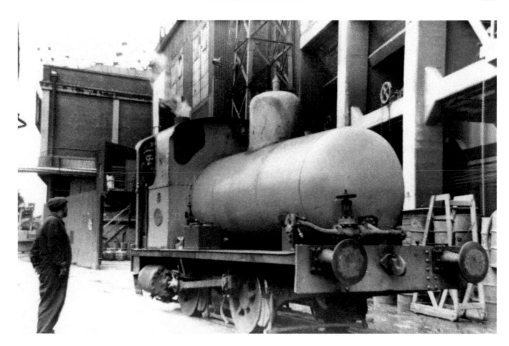

Clarence Dock Power Station, Liverpool on 28 August 1959, and 0-4-0F Andrew Barclay Sons & Co. 1917-built fireless loco *Bea* No. 1 is carrying works No. 1560. Not thought to be a survivor. (Maurice Dart/Transport Treasury)

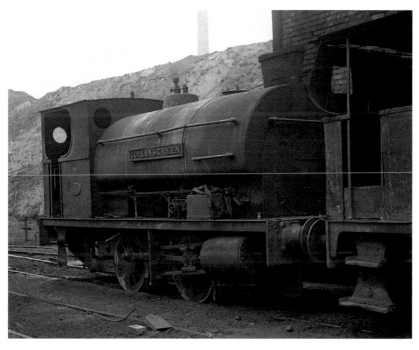

This 0-4-0ST named *Collins Green* was built by Peckett & Sons in 1933 as works No. 1762. Seen here at Ravenhead Colliery, St Helens, Lancashire on 30 April 1967, it was scrapped on-site in July 1973. (Maurice Dart)

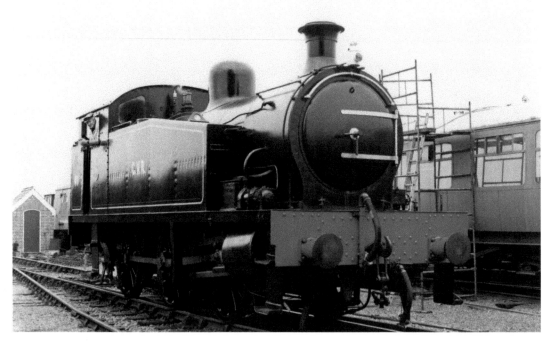

Another photograph of RSH 0-6-0T loco No. 40 on the Weardale Railway. (Author's collection)

This 0-6-0ST is named *King* and was built by Peckett & Sons in 1902 as works No. 957 for use in the Lancashire Coal Fields, ending up at Cronton Colliery around May 1966. It was scrapped on-site by Mee & Cocker in November 1968. (Maurice Dart)

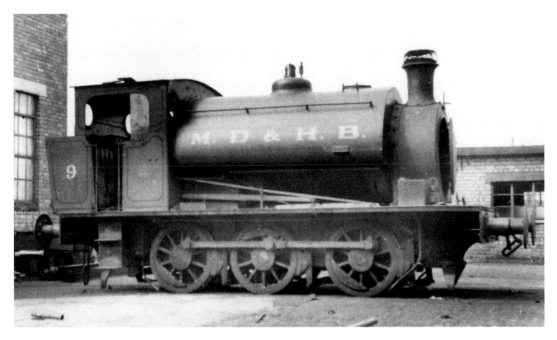

M.D & H.B 0-6-0ST No. 9 was built by The Hunslet Engine Co. as works No. 1984 in 1940. Seen here on 28 August 1959 on shed at Princes Dock. Not shown as a survivor. (Maurice Dart/ Transport Treasury)

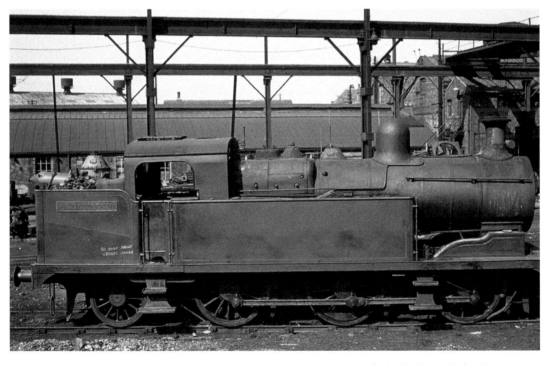

Another former NSR 0-6-2T, *King George VI* is seen here. Built in 1913 at Stoke, it was withdrawn in January 1965 and scrapped in May 1966. (A. Darby collection)

Ravenhead Colliery on 30 April 1967 sees 0-4-0ST *Westwood* in company with *Collins Green. Westwood* was built by Hudswell Clarke & Co. in 1913 as works No. 1036, and was scrapped on-site by Mee & Cocker Ltd during October and November 1968. (Maurice Dart)

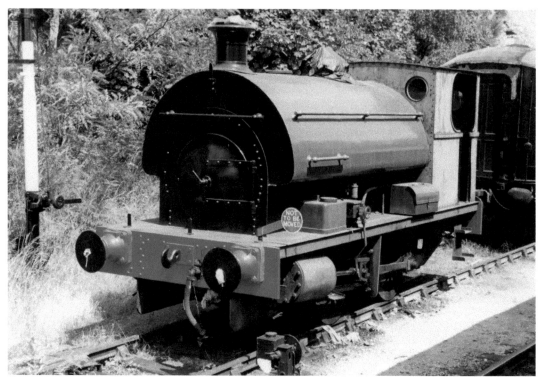

Another Peckett 0-4-0ST is works No. 1738 of 1928, which was new to Hams Hall Power Station as No 4. Subsequently, the CEGB declared it surplus to requirements in 1968 and it passed into preservation and moved to the Severn Valley Railway (SVR), but is now based at the private Titley Junction station. Seen here in 1988 at Bewdley (SVR). (Author's collection)

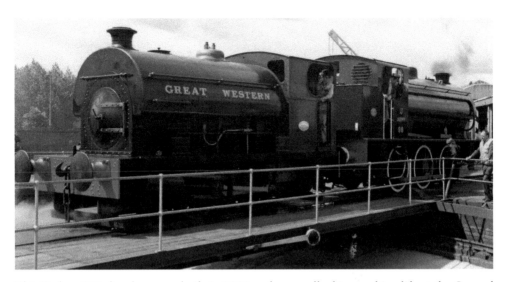

This Peckett W7 class loco was built in 1941 and spent all of its working life at the General Electric Co. (GEC) factory at Swinton near Rotherham as No 6. After its service it went to Tyseley, where it was restored. It is seen here at Tyseley in 2004 in company with Austerity 0-6-0ST WD 98 *Royal Engineer*, which was renumbered WD198 and is now on the Isle of Wight Steam Railway. (Author's collection)

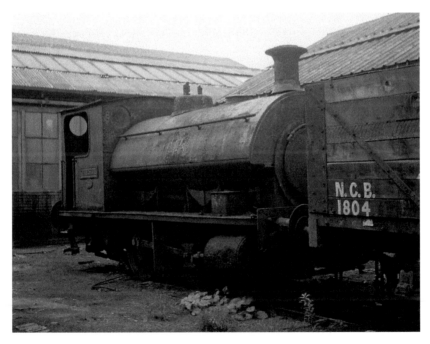

This 0-4-0ST loco named *Kearsley* was built by Kerr, Stuart & Co. in 1919 as works No. 4129 (though shown in contemporary records as 3123/1918) for use in Manchester Collieries and was at Ashton Moss Colliery prior to 1959, transferring to Wheatsheaf Colliery & Screens, Pendlebury. Seen here at Walkden Central Workshops on 17 August 1966, it was subsequently sent to Maudland Metals Ltd of Preston in February 1967 for scrap. I cannot find any trace of a second *Kearsley* 0-4-0 by Kerr, Stuart & Co. (Maurice Dart)

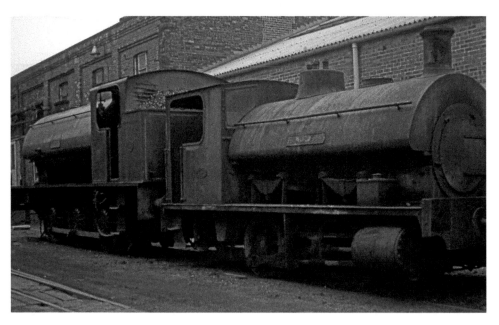

This is Walkden Central Workshops around 1967. Seen here is an unidentified Austerity 0-6-0ST and 0-4-0ST *Fairfield,* which was a Kerr, Stuart-built loco of 1919 and works No. 4025. It was scrapped on-site in September 1968. (A. Darby collection)

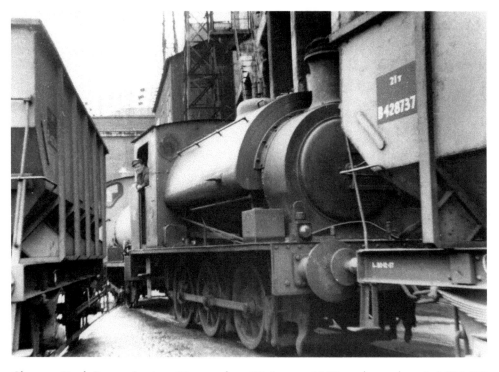

Clarence Dock Power Station, Liverpool on 28 August 1959, and seen here is MD&HB No. 8, built in 1937 by The Hunslet Engine Co. as works No. 1828. Behind it and possibly double-heading is an 0-4-0F fireless loco, No. 2 *Bea.* (Maurice Dart/Transport Treasury)

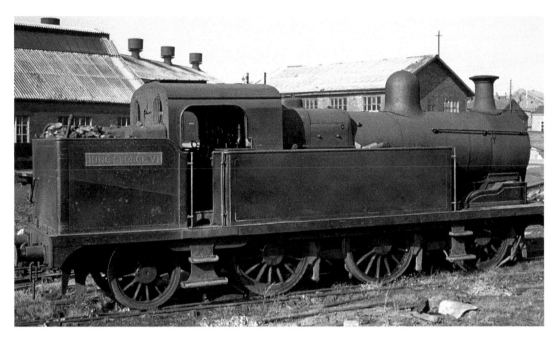

Former NSR 0-6-2T *King George VI* is seen here. Built in 1913 at Stoke, it was withdrawn in January 1965 and scrapped in May 1966. (A. Darby collection)

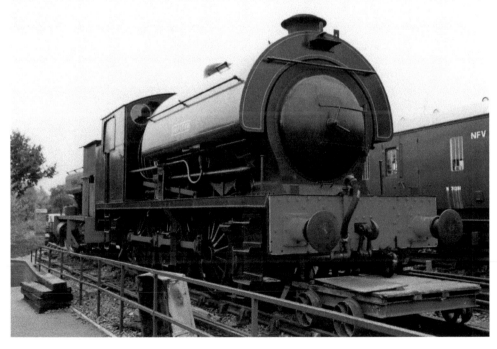

Another of the Corby Steel Works batch of 0-6-0ST is seen here in 1988, out of use at Castle Hedingham on the Colne Valley Railway. Built in 1950 as No. 7671, it became Stewart & Lloyd No. 60 *Jupiter* and was sold into preservation in 1969, ending up at the CoVR. (Author's collection)

This diminutive 0-4-0ST was built by Peckett & Sons in 1942 as No. 2031 for the Exeter Gas Works. Surviving an air raid in May 1942, it was preserved around 1971 on the SDR, where it resides in the museum there. Seen here in 1979 at Buckfastleigh, out of use. (Author's collection)

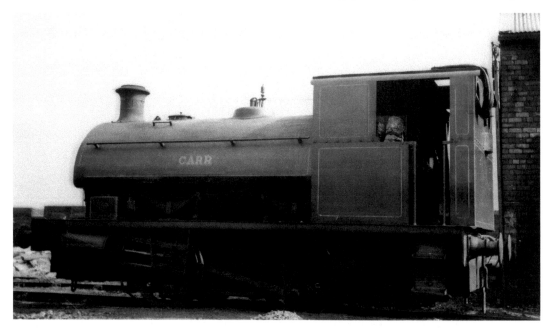

Another view of *Carr* at Astley Green Colliery on 23 July 1962. (W. A. Darby collection)

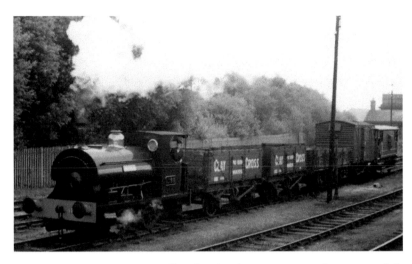

M5 class 0-4-0 No. 1163 at Barrow Hill with a freight train on 14 July 2001. Built by Peckett & Sons in 1908 and delivered new to Cefnstylle Colliery, South Wales. Initially given the name *Cefnstylle*, the name was changed to *Cefngoleu* when the colliery changed its name. Upon closure it moved to Bethlwyd Colliery for storage. Rebuilt by Peckett in 1921, it was stored until 1937 then purchased by Whitehead, Hill & Co. for use on the Oakfield Wireworks system. When that closed in 1966, by that time it was named *Whitehead* and was sold to a private buyer and stored until 1971 at Highbridge, when it was purchased by members of the Great Western Society and moved to the West Somerset Railway. In 1982 the locomotive was sold and moved to the Southport Railway Centre and after a six-year overhaul returned to steam at the Preston Docks Maritime Festival before moving to the Manchester Museum of Science & Industry in 1998. It is now at the Midland Railway Centre. (R. J. Buckley – Maurice Dart collection)

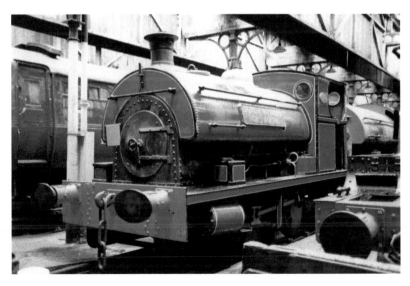

This Peckett was built in 1941 as works No. 1999, for Crowlands Gas Works, Southport. In 1958 it was transferred to Darwen Gas Works and was sold on by the North Western Gas Board in 1963. It moved to the KWVR, then in 1969 was used in the film *The Virgin and the Gypsy* at Matlock. It then went on long-term loan to Steamport in Southport, and is now at the RSR. Seen here in Steamport in 1988. (Author's collection)

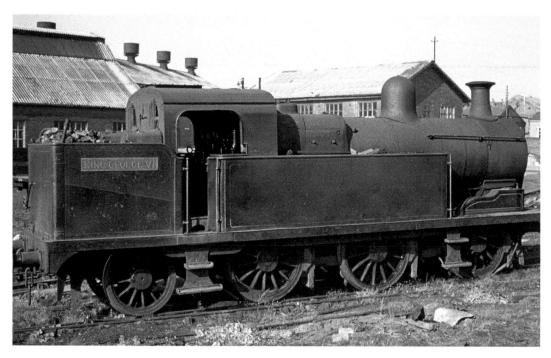

Former NSR 0-6-2T *King George VI* is seen here. Built in 1913 at Stoke, it was withdrawn in January 1965 and scrapped in May 1966. (A. Darby collection)

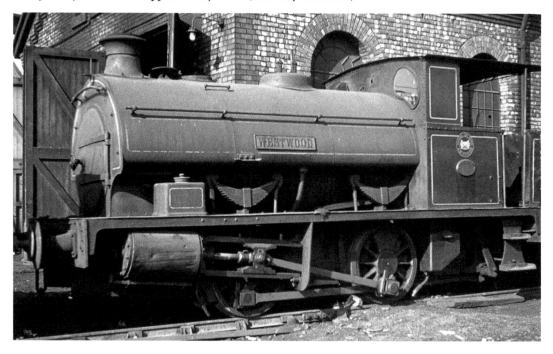

This diminutive 0-4-0ST, named *Westwood,* was built in 1913 by Hudswell Clarke as No. 1036 but little is known about it and it does not appear in contemporary records of preserved examples. (A. Darby collection)

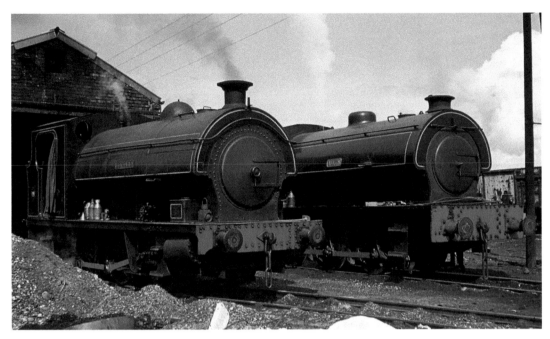

This is *Edward*, Hawthorn Leslie-built No. 3184 of 1916, which was scrapped on-site in October 1968. Next to it is smartly turned-out Austerity *Allen*, a Hudswell Clarke product of 1944 that carried the works No. 1777 – WD 71500. It was scrapped on-site in September 1968. (A. Darby collection)

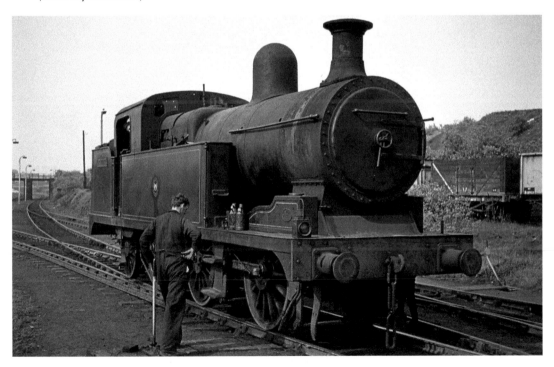

Another photograph of *Sir Robert*, at Astley Green *c.* 1962. (A. Darby collection)

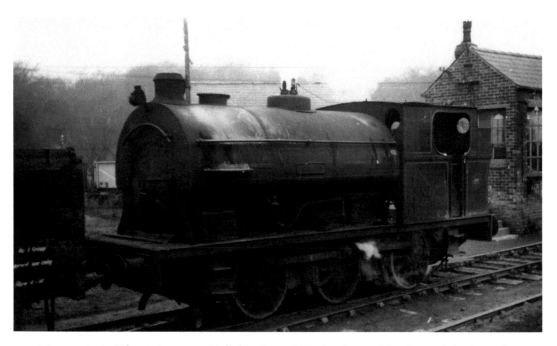

Here again is *Atlas*. It is seen at Walkden Central Works along with others of the Austerity class (including a Giesl ejector example) and all appear in withdrawn condition *c.* 1966. It was scrapped on-site in September 1968. (A. Darby collection)

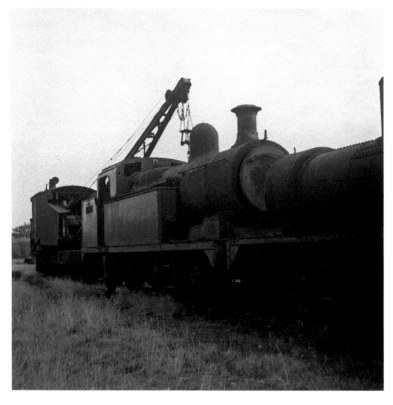

Another of the NSR five is *King George VI*, which is seen here on 17 August 1966 at Walkden. Former L.M.S. No. 2257, and NSR 69, it donated its bunker and tanks to the original No. 2 in 1965 before being scrapped in 1969 (though one record shows it as scrapped in May 1966), despite attempts to preserve it. (Maurice Dart)

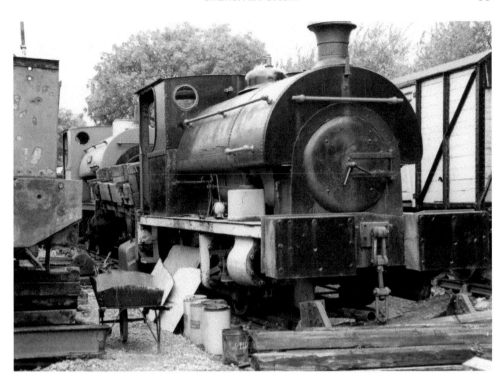

This loco is a R2 class Peckett built in 1912 as No. 1257 *Uppingham* for James Pain's Ironstone Quarry. Seen here in 1988 at Rocks by Rail Museum in Cottesmore, where it still resides. (Author's collection)

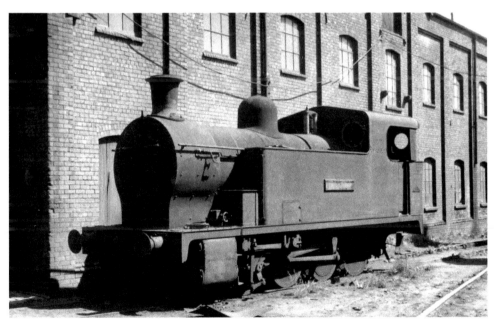

Nothing is known of the 0-8-0T loco, which appears to be stored – possibly at the Walkden Central Works. (A. Darby collection)

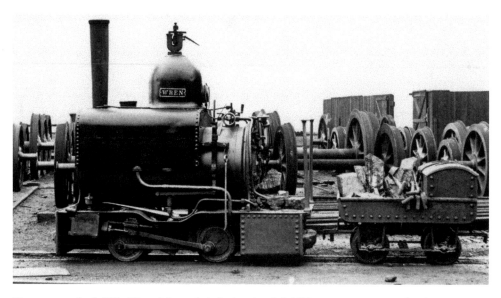

Here we see the L.Y.R., Horwich works' diminutive 0-4-0ST narrow-gauge works shunter *Wren*. It was built by Beyer Peacock in 1887 at a cost of £268. The internal narrow-gauge works system extended to 7½ miles when built by the L&Y Railway and *Wren* worked there from when it was purchased to when it was officially withdrawn in 1963. Now part of the National Collection in York, she was one of eight similar engines introduced between 1887 and 1901. *Wren* carried a strongbox on the tender for distributing wages throughout the works. (Maurice Dart collection)

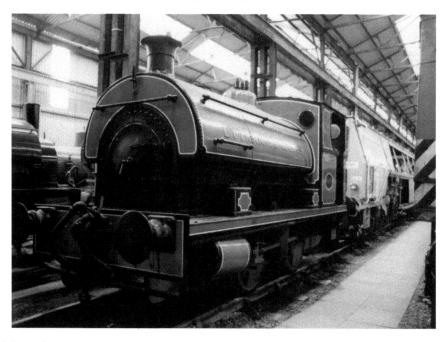

Built by Peckett & Sons in 1949 as works No. 2111 for Blackpool Gasworks as their No. 1 *Lytham St Annes*. When it was withdrawn from industrial service it was preserved privately by J. Morris and was exhibited in his Motive Power Museum at Lytham St Annes. In 1984 it was sold to a member at Peak Rail. It is now at the Stainmore Railway on loan. (Author's collection)

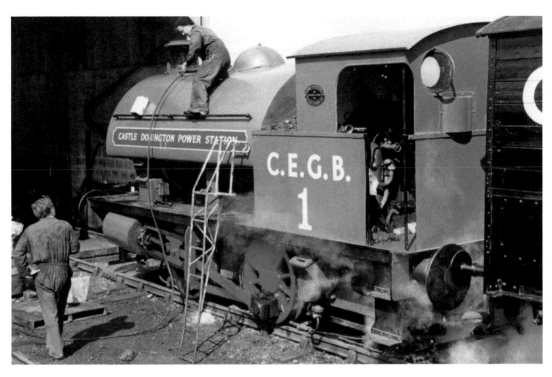

This 1954 RSH-built 0-4-0ST is No. 7817 and is one of two for the Castle Donnington Power Station. *CEGB 1* is seen here at Foxfield in 1988, but now resides at the MRC, Butterley. (Author's collection)

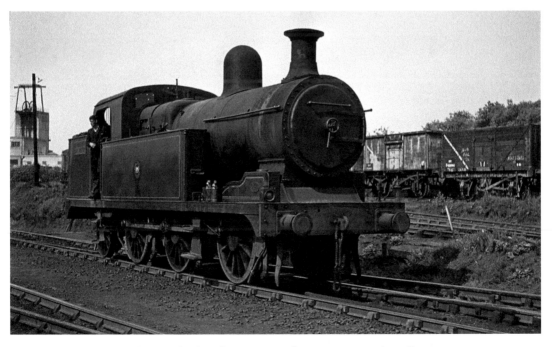

Former NSR *Sir Robert* at Ellenbrook on 9 September 1962. (A. Darby collection)

This 0-6-0ST is a former L&Y locomotive numbered 752, built in 1881 by Beyer Peacock Co., Manchester as works No. 1989, originally as a tender engine to a design by Barton Wright. In 1896 it was rebuilt at Horwich Works as a saddle-tank to an Aspinall design, following a need for shunting locomotives. After Grouping in 1923 it was renumbered No. 11456 by the LMS. In 1937 it was sold to the Blainscough Colliery Co., Coppull, Lancashire. In 1947, following the formation of the NCB, the engine came to be in the possession of the North Western Division of the NCB. In 1967 it was purchased from the NCB for preservation. Since it had been lying at Parsonage Colliery, where it is seen here on 7 May 1967, for nine years, the locomotive was in poor condition. In November 1971 the locomotive was moved to Haworth on the KWVR. The chimney on 752 was that previously used by No. 11305. (Maurice Dart)

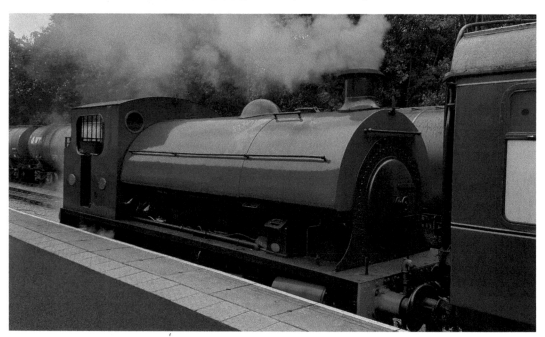

No. 3931 *Linda*, a Hawthorn Leslie 0-6-0ST, in action at the Ribble Steam Railway on 28 July 2019. Built in 1938 as one of fourteen for Stewarts & Lloyds Steelworks at Corby and given the number 21, it worked there for over thirty years. It was overhauled in 1971 by the then British Steel Corporation (BSC), receiving a spare boiler, and was the last to be overhauled in this way and believed to be the only steam loco to carry the BSC logo. It has been operated and stored at various heritage railways before ending up at RSR. (Richard Jones)

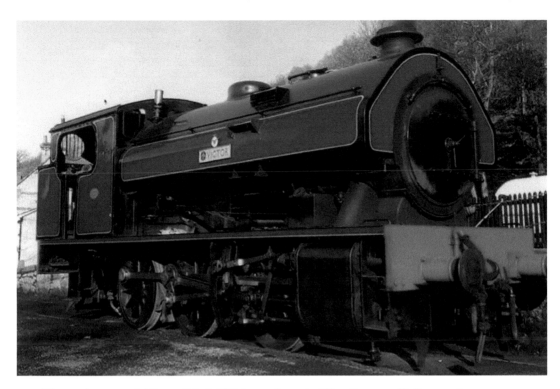

Victor, the powerful Bagnall 0-6-0ST, formerly at the West Somerset Railway, raises steam at Haverthwaite station on the L&HR on 10 August 2018. Built in 1951 for the Steel Company of Wales at Port Talbot, it was a high specification and excellent design. It was sold six years later to Austin's at Longbridge, along with one other of the original three. It could be seen at various heritage railways over the years until a private buyer purchased it for use on the L&HR, where it was overhauled and returned to service in 2015. (Richard Jones)

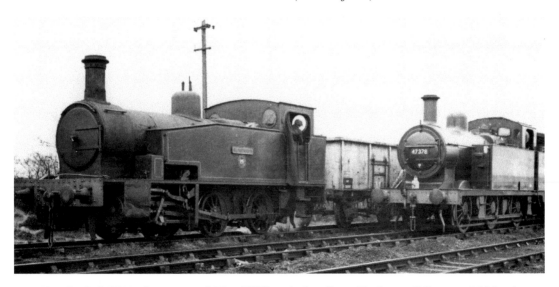

Hunslet 0-6-0T *Bridgewater* and No. 47378 at Astley Green Exchange Sidings on 16 March 1963. (A. Darby collection)

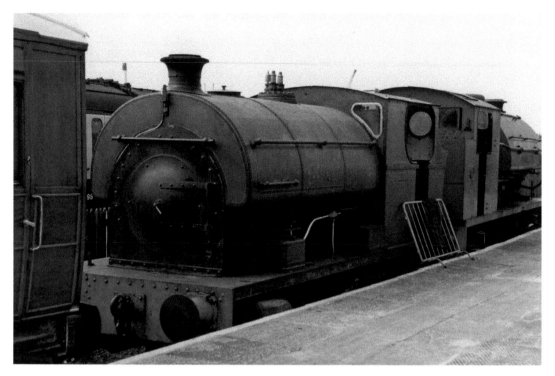

This Peckett 0-6-0ST is a B3 Class, built in 1942 as No. 2000 for Sproughton Sugar Beet Factory at Ipswich. Preserved in 1977, it has resided at a couple of locations before ending up at Barrow Hill Roundhouse. Seen here in 1988 at North Woolwich Old Station Museum, East London. (Author's collection)

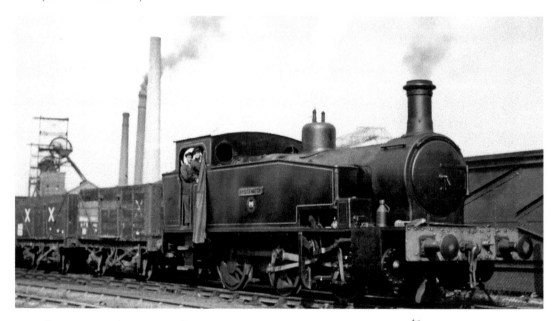

Shunting at Astley Green Colliery *c.* 1967 with Hunslet 0-6-0T *Bridgewater*, which was built in 1924 as No. 1475 and scrapped on-site in October 1968. (A. Darby collection)

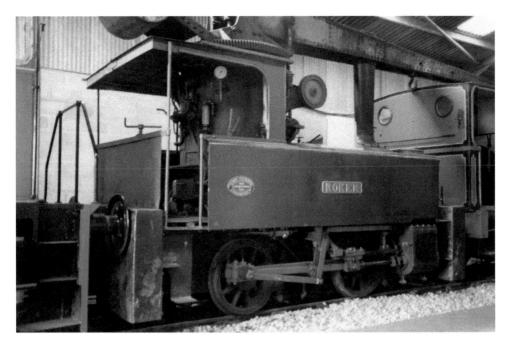

RSH 0-4-0CT No. 7006 *Roker* was built in 1940, but the parts (along with No. 7007) were actually part of a cancelled order dating from 1918. They were stored until assembled under RSH ownership in 1940 for the shipbuilding yard of William Doxford & Sons, Sunderland. The loco is on extended loan to Beamish Museum from the Foxfield Railway. (Author's collection)

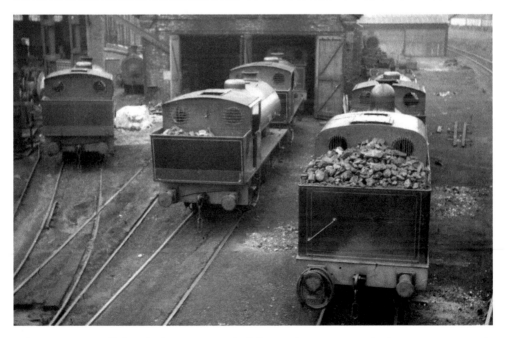

A busy scene in Walkden Shed *c.* 1962. On the left is *Peckett*, a 0-6-0ST built in 1890 as No 518, and *Warrior.* Centre is *North Stafford* (in shed), *Revenge* and *Respite.* Right is: *Charles* (Giesel) and *King George VI.* (W. A. Darby collection)

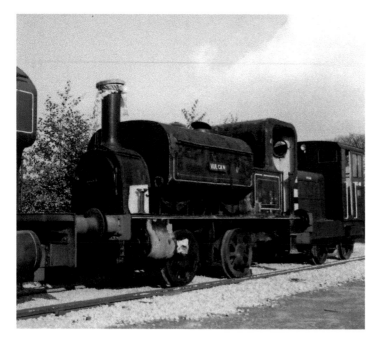

Vulcan 0-4-0ST *Vulcan* seen at Peak Rail in Buxton on 24 October 1987. Built by Vulcan Foundry in 1918, it spent its working life shunting at the works. It appears to have started its preservation life at Peak Rail, but did not operate there. It then moved to Barrow Hill Roundhouse, where it was restored and it is recorded as being in steam there in 2014. Since then, it has visited a number of heritage railways and Beamish Museum. (Maurice Dart)

Next to the Carriage Shed at Edge Hill on 17 August 1966, we see an ancient but unidentified former L&Y 0-4-4T loco, used as a carriage heating boiler. (Maurice Dart)

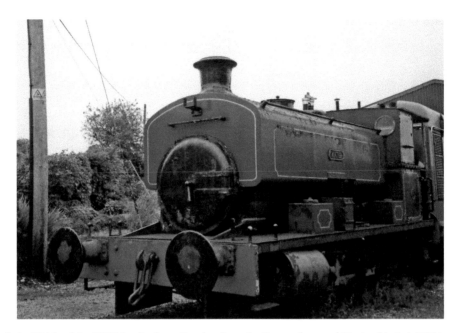

Built in 1946 as No. 2221 by Andrew Barclay Sons & Co., and named *Katie,* this 0-4-0ST is now kept at the Churnet Valley Railway in Cheddleton, Staffordshire. Seen here on 21 August 2017. Built in 1946 and delivered new to Devonport Dockyard at Plymouth, where it was No. 19 before being renumbered as No. 2. It worked at Devonport until it was withdrawn from service in May 1966. (Maurice Dart)

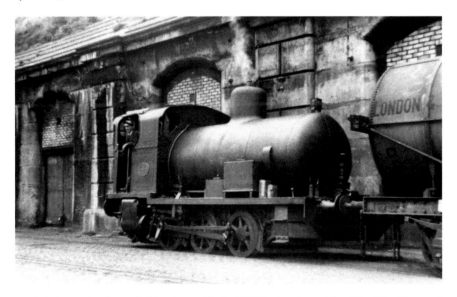

Not much information is available about this 0-6-0F Fireless loco, No. 43 of the Mersey Docks & Harbour Board. It is believed to have been built by Avonside Engineering Co. around 1918 as works No. 1573. These types of loco were used in areas where there was a high risk of fire or explosion, and were powered from a reservoir of compressed air or steam, which is filled at intervals from an external source and were superseded by diesel and electric types. Seen here on 28 August 1959 on Dingle Oil Jetty, Liverpool. (Maurice Dart/Transport Treasury)

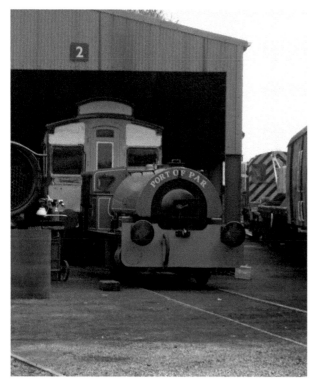

This photo depicts one of the pair of diminutive Port of Par 0-4-0ST locomotives, *Alfred* and *Judy*, this being *Judy* – seen here on 30 March 2012 outside the Carriage Shed No. 2 road at Bodmin General station on the Bodmin & Wenford Railway. Built in 1937 as No. 2572 by W. G. Bagnall of Stafford, both locos are preserved and their height is clearly demonstrated here. The cut-down cab was due to a very low bridge under the GWR main line adjacent to Par Docks in Cornwall, where access was required to the China Clay stores on Par Moor. (Robert Powell**)

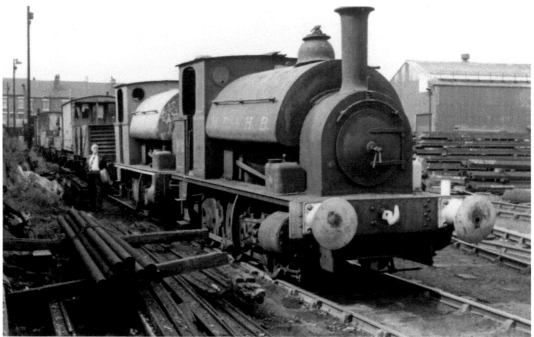

Mersey Docks & Harbour Board No. 21. at the Middleton Railway, Leeds on 2 Sept 1967. Built by Avonside of Bristol as No. 1671 in 1913, it was scrapped at the Middleton Railway around 1970. (A. R. Wilson – Maurice Dart collection)

The Hunslet Austerity 0-6-0ST

No book about industrial steam locomotives would be complete without a chapter dedicated to the ubiquitous Austerity Saddle Tanks.

The British railway preservation movement and our present-day heritage railways owe a debt of gratitude to the various industries that kept their Hunslet design steam 0-6-0ST locomotives going long after steam had disappeared from the national network.

These rugged, well-designed small engines were powerful and readily available, and there cannot be many, if any, preservation schemes or heritage railways that have had at least one example over the years.

The original design prototype suggested for an 0-6-0T was the ex-LMS Jinty, and it was only the perseverance of Edgar Alcock, the Hunslet chairman, that convinced the Ministry of Supply that the Hunslet 0-6-0ST would be more suitable from a production viewpoint, and greater route availability. One condition was that the locomotive must be capable of performing at least two years of intense hard work, irrespective of the state of the track, and be capable of starting a 1,000–1,100-ton train on the level and 550 tons on a 1 in 100, and 300 tons on a 1 in 50 gradient.

Many other companies built this type of loco to the same design and pattern, including Andrew Barclay Sons & Co. Ltd, Robert Stephenson & Hawthorns Ltd, Vulcan Foundry Ltd, W. G. Bagnall Ltd, and Yorkshire Engine Co. Ltd.

Reputable sources show that in total 484 were built over a twenty-one-year period, such was the success of the design, and about eighty survive in preservation – some already in use, while others are awaiting attention.

Weighing 48.2 tons with an axle load of 16.35 tons, they had two inside cylinders of 18 x 26 inches (457.2 x 660.4 mm), with a wheel diameter of 4 feet 3 inches (1295.4 mm) on an 11-foot (3352.8 mm) wheelbase. Operating at a boiler pressure of 170 lbs with a heating surface of 960 sq feet (89 sq m), and grate area of 16.8 sq feet (1.56 sq m) with a tractive effort of 23,870 lbs (106,179 newtons) and water capacity of 1,200 gallons (5,455 litres) and coal capacity of 45 cwt (2,286 kg).

They were classed as 'Austerity' because they were devoid of anything that was not needed, just like the hundreds of much larger Austerity 2-8-0 and 2-10-0 locomotives built for main line use during the war for use at home and abroad. They were a true classic in design, and outstanding in reliability and performance.

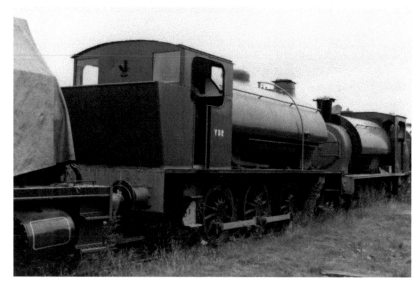

WD70066 (No. 2414) (S112) *Spitfire*. This was one of eight built for Stewarts & Lloyds Ltd in 1941 for quarry work, but they were never used. They were classed as 50550 class and became the true forerunners of the Austerity class, though they were different in specification. Three passed to the WD and this one was based at Long Marston Central Engineers Depot, which had 45 miles of track. It then passed to the NCB and was withdrawn in 1972 in poor condition. Now resident on the E&BASR under restoration. Seen in 1982 at Embsay. (Author's collection)

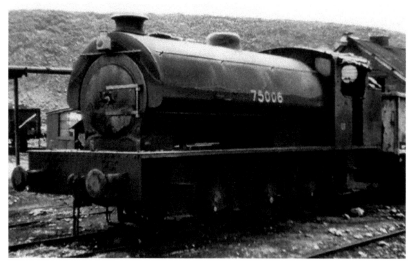

WD75006 (No. 2855). This photo of Hunslet of 1943 shows it working for the NCB-OE Onllwyn on New Year's Day 1969. It first went to NCB Llanharan Disposal Point as No. L1 after its WD service. Built as No. 2855, it was only the seventh Austerity to be built. It was shown as being rebuilt in 1953 and given a works number of 1725, which was a series by the Hudswell Clarke Company, but I could not find any serious evidence to support the idea that it belonged in this series. It survives as the oldest Austerity still in existence in the UK, carrying the number 68081 at times, which is numerically following on from the last J94 type of BR. Last shown as awaiting a new boiler on the NVR. (H. Llewelyn*)

An unidentified Austerity class at an unknown colliery location in Lancashire. *c*. 1964. (A. Darby collection)

Another Austerity pictured moving stock around the colliery site at Walkden, *c*. 1964. (A. Darby collection)

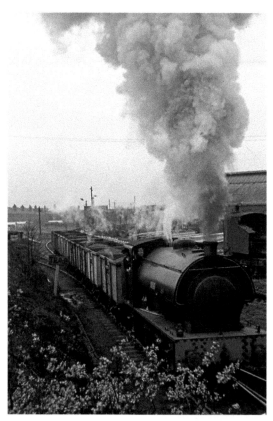

Left: An unidentified Austerity class 0-6-0ST moving a train around the colliery site, *c.* 1964. (A. Darby collection)

Below: WD75006 (No. 2855) was a Hunslet locomotive built in 1943 for use on military railways and collieries and only the seventh production Austerity 0-6-0ST to be constructed. It was withdrawn in 1973 and kept for spares. In 1976 it was loaned to the NVR, becoming the earliest member of the class to be preserved. After overhaul it was given the number 68081, following on from the last BR number. Seen here at NVR, Wansford in 1988, it shares the shed with another classic – a 1979 Datsun Sunny, which considering it is just eight years old, is not wearing particularly well! (Author's collection)

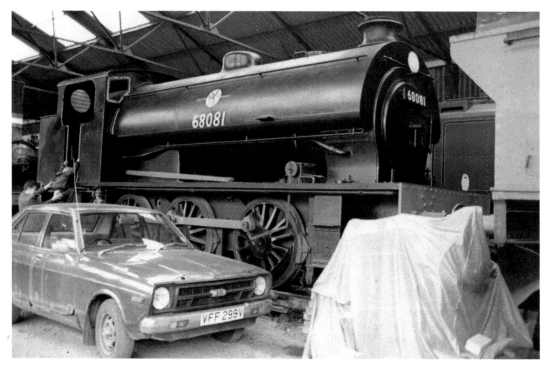

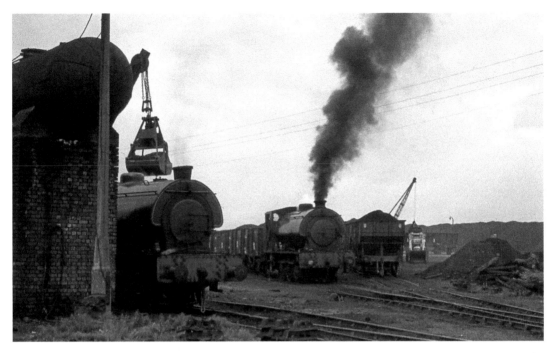

Another very atmospheric photograph from 1968, we see two unidentified Austerity 0-6-0ST locos working at Astley Green Colliery. (J. James)

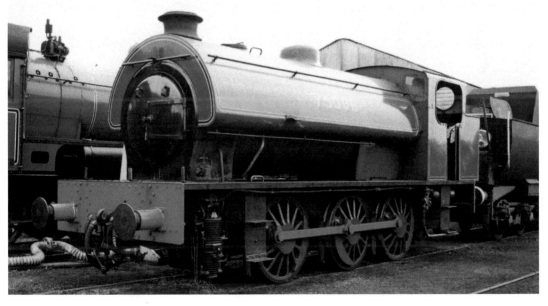

WD75006 (No. 2855) Hunslet built in 1943 for use on military railways and collieries, and only the seventh production Austerity 0-6-0ST to be constructed. It was withdrawn in 1973 and kept for spares. In 1976 it was loaned to the NVR, becoming the earliest member of the class to be preserved. After overhaul it was given the number No. 68081, following on from the last BR number. Seen here at NVR, Wansford in the 1990s. (Author's collection)

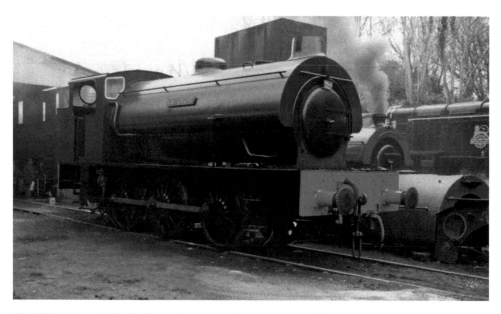

WD75008 (No. 2857) *Swiftsure.* This is another Hunslet-built loco from 1943. After delivery to the LMR it was stored, then in 1944 sent to France, returning to the UK in 1946. It then worked in various collieries until it was withdrawn in 1986 and sold into preservation. It moved to the B&WR in 1987 and stayed until 2006. Now owned by Rail & Road Steam Services, it is last noted as working on the Mid Norfolk Railway. Seen here at Bodmin General in 1992. (Author's collection)

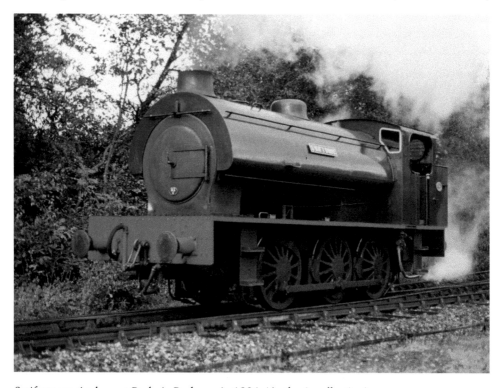

Swiftsure again, here at Bodmin Parkway in 1994. (Author's collection)

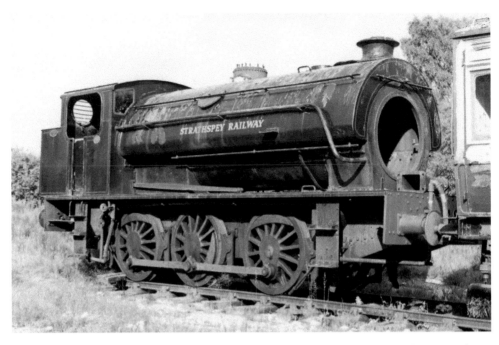

WD75015 (No. 2864). Built in 1943 by Hunslet for the WD, it was stored at Melbourne Military Depot in Derby until loaned to the Ministry of Fuel & Power in December 1945, thence to various collieries for twenty years from April 1946. It moved to the Strathspey Railway in 1976, where it was stored from 1980 until 2018, when it moved to the Aln Valley Railway. Seen here in 1988 stored in poor condition at Boat of Garten. (Author's collection)

WD75040 - WD106 (No. 2889) *Spyck*. An MoS Austerity 18-inch 0-6-0ST, seen here at Woodham Brothers Scrapyard in Barry in October 1964. Built by Hunslet in 1943 for the WD, it was used on the LMR. (H. Llewelyn*)

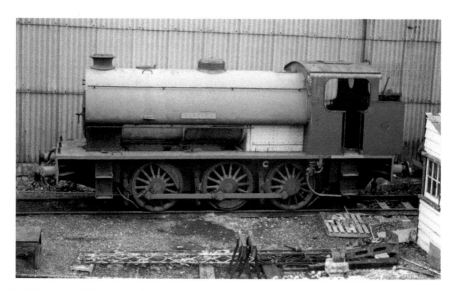

WD75041 (No. 2890) was built in 1943 by Hunslet of Leeds as an Austerity 0-6-0ST. It entered service with the War Department Stores Depot at Richborough in Kent in December 1943. It was numbered 107 when moved to the LMR in 1944, hauling passenger trains and named *Foggia*. Withdrawn in the 1960s, it was sold back to Hunslet for experimental smoke emission modifications. Emerging as No. 3883, it went to the NCB and in 1976 was purchased for preservation, subsequently residing at several heritage railways including SDR. Sold to the Mid Hants Railway in the 1990s, it was rebuilt and converted from a Saddle-tank to 0-6-0, with a former LMS Fowler tender. Now No. 2890, it is based on the East Lancashire Railway. Seen here in 1987 at Buckfastleigh. (Author's collection)

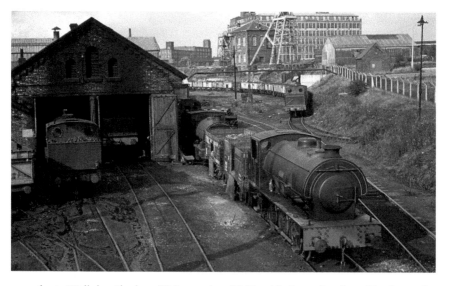

An atmospheric Walkden Shed on 29 September 1962, with Austerity class *Charles*, and *James*, 0-4-0ST *Westwood*, and *NSR No2* among others. *Charles* was a Hudswell Clark of 1944 as No. 1778, WD 71501, and is presumed scrapped. *James* was a Robert Stephenson & Hawthorn product built in 1944 as No. 7175, WD 71521, and was scrapped in 1968. The 0-4-0ST was also built by HC as No. 1036 in 1913 and is also believed not to survive. (W. S. Darby – A. Darby collection)

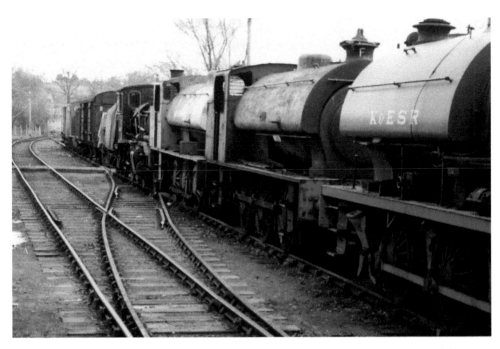

WD75050 (No. 7086). This was the first Austerity built by RSH in 1943. Painted khaki in readiness for D-Day, it was shipped to France in December 1944 and thence to Belgium. It returned to the UK in 1946 and was put on colliery work until sold into preservation in 1976, then resold to the K&ESR in 1979 before moving to Butterley, then Sellinge, then Swanage, then E&BASR. It is seen here at Rolvenden in 1983. (Author's collection)

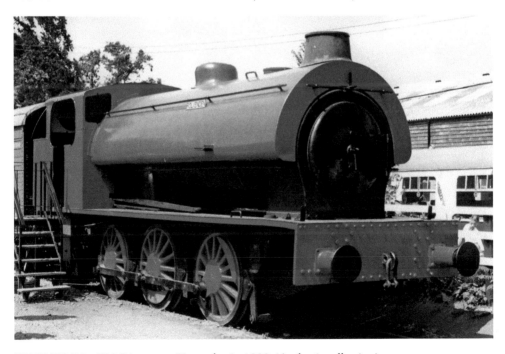

WD75050 (No. 7086) is seen at Tenterden in 1988. (Author's collection)

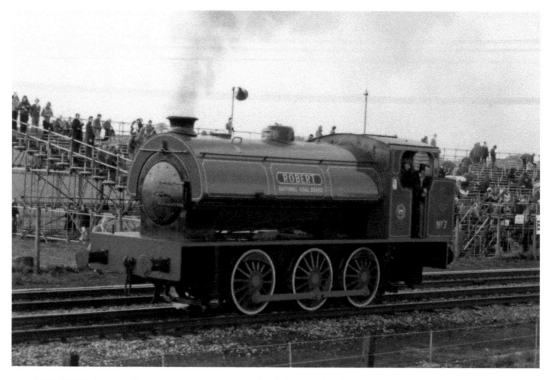

WD75091 *Robert* (No. 1752) (No. 68067), built by Hudswell Clarke in 1943. Purchased from MoD by NCB in 1950 for colliery work, it went on to several sites including Bold Colliery at St Helens in 1978, where it was named *Robert*. While there it was prepared for the Rocket 150 celebrations at Rainhill. Withdrawn in 1982 and sold for preservation, it moved to the GCR and after restoration was given the number 68067 from a similar BR loco (WD 71474) that had been scrapped in 1971. It is seen at Rainhill in 1980. (Author's collection)

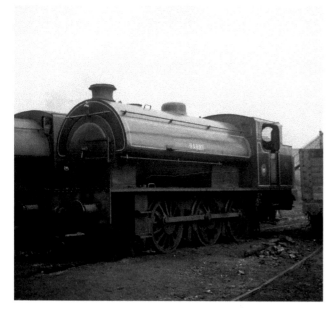

WD71499 (No. 1776) *Harry*. Another Austerity 0-6-0ST of 1944 Hudswell Clarke, it was delivered to the Ministry of Fuel & Power for use at Darton opencast coal mine in Yorkshire in June 1944. It soon moved to Garswood Hall Colliery Co. at Wigan, before going to Hoyland Moor opencast mine at Elsecar in Yorkshire in August 1945. In March 1948 it was moved to Peel Hall Screens at Little Hulton in Lancashire, before returning to Yorkshire in February 1952 at Barnoldswick opencast mine, which by this time was owned by the NCB. It is seen here at Walkden on 17 August 1966. It is currently under restoration for the E&BASR. (Maurice Dart)

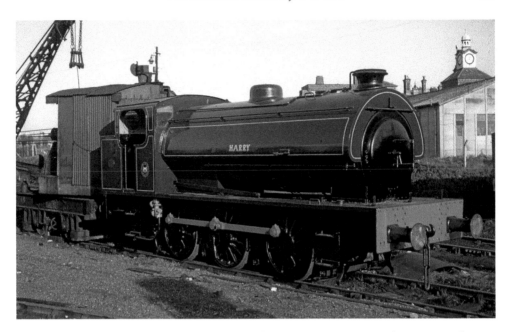

WD71499 *Harry*. Here we see a Hudswell Clarke Austerity 0-6-0ST working at an unknown location and date in one of the former Manchester Collieries (Walkden Railways) sites. Built in 1944 as one of a batch of six, she survived into preservation in 1976 and is thought to be awaiting overhaul, destined for the E&BASR. (A. Darby collection)

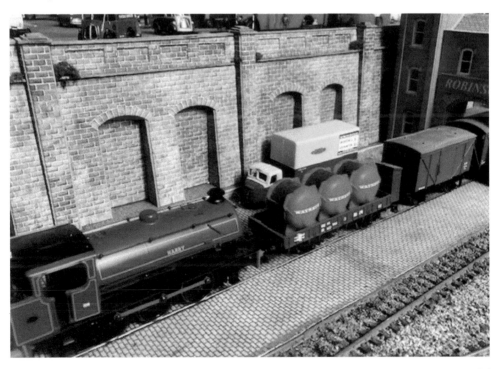

Here is *Harry* again, but this time it is shunting at the local brewery on my Peterswood model railway layout in 2020. (Author)

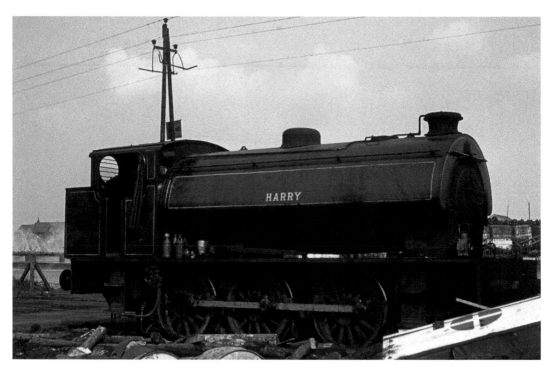

Another photograph of Austerity 0-6-0ST *Harry* at Astley Green *c.* 1964. (A. Darby collection)

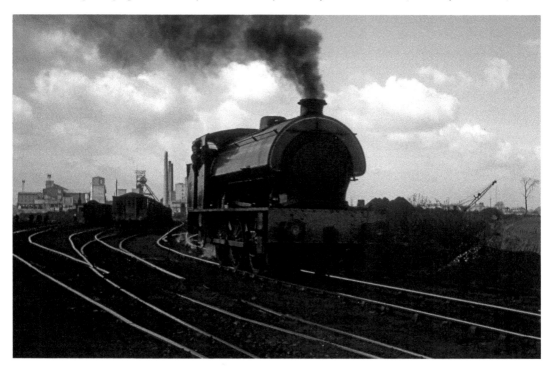

Hudswell Clarke 1944-built Austerity loco *Harry* at Astley Green Colliery, *c.* 1964. (A. Darby collection)

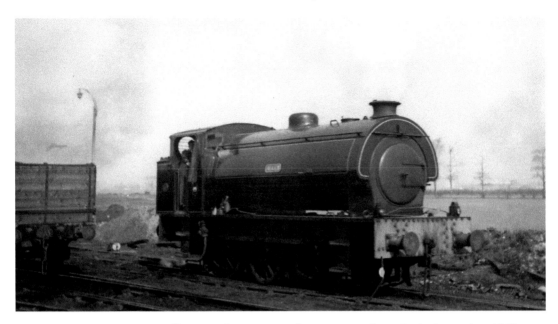

WD71500 (No. 1777) *Allen* at Astley Green Colliery, scrapped on-site in September 1968. (A. Darby collection)

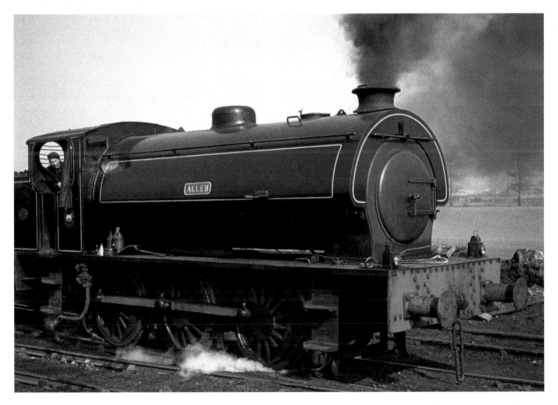

WD71500 *Allen*. This smartly turned-out Austerity was a Hudswell Clarke product of 1944 and carried the works No. 1777. Scrapped on-site in September 1968. (A. Darby collection)

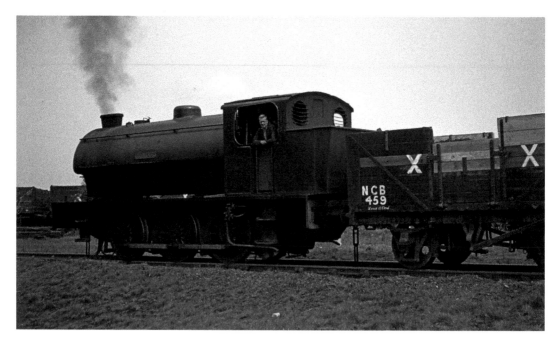

WD71501 (No. 1778) *Charles*. Giesl ejector-fitted Austerity is seen here at Astley Green. Built in 1944 by Hudswell Clarke, it transferred to Ladysmith Washery in Cumbria in 1967 but it is assumed it was withdrawn and subsequently scrapped. (A Darby collection)

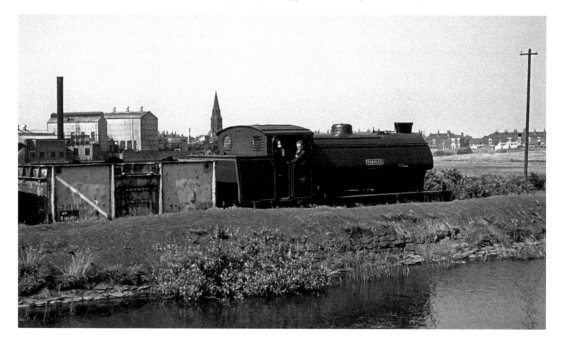

WD71501 *Charles*. This is newly outshopped, fitted with a Giesl ejector. It is seen here adjacent to the Bridgewater Canal at Astley Green, and was built in 1944 as No. 1778 by Hudswell Clarke. It transferred to Ladysmith Washery in Cumbria in 1967 but it is assumed it was withdrawn and subsequently scrapped. (A. Darby collection)

WD71501 (No. 1778) *Charles*. Seen here on 17 August 1966 at Walkden Central Works, it is an Austerity 0-6-0ST built for the Ministry of Supply by Hudswell Clarke in 1944. It is presumed to not have survived. (Maurice Dart)

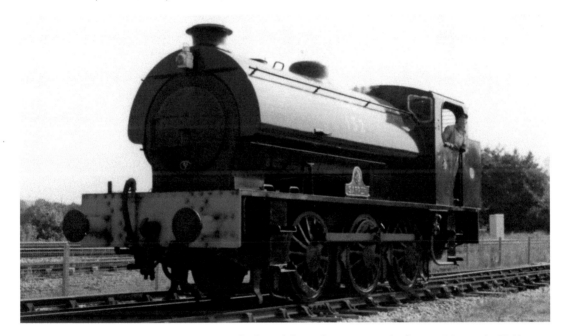

WD75113 *Sapper* (W132) was a Hunslet loco delivered new to an RAF base at Bicester in 1944. The locomotive was moved to the Cairnryan Military Railway at Stranraer in December 1950. There was a need to dispose of large amounts of surplus ammunition at the end of the war; the quickest and cheapest way was to dump it at sea. Over the next few years, the railway was used to carry countless trains of explosives, including a horrible cargo of German nerve gas that arrived by sea from Wales. All of this was loaded onto unwanted ships, like the *Empire Claire*, before being scuttled at sea. This loco can normally be found residing on the East Lancs Railway. Seen here in 1996 on SDR. (Author's collection)

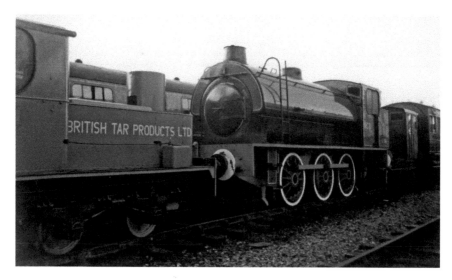

WD75118 (S134) (No. 3168) *Wheldale* is a 0-6-0ST of the Hunslet Engine Company, built in 1944 and seen here at Embsay on 31 October 1999. It is standard Austerity, from one of the first batches to be built by Hunslets. Although it is referred to by its NCB number, S134, it became part of the Army's fleet, based at Bicester, as No. 134. It would appear that the coal board simply added an 'S' prefix later! It came to the E&BASR from Wheldale Colliery, Castleford, where it had been working since the early 1980s. (Maurice Dart)

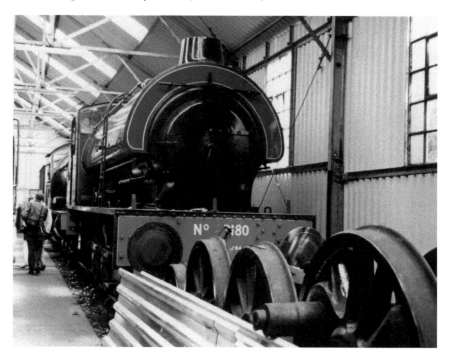

WD75130 (No. 3180) *Antwerp* was built by Hunslet in 1944 and was used on the LMR, then saw war service in Belgium before working various NCB collieries and being preserved in 1979. It is normally a resident of the NYMR, but is currently in storage at Sellindge. Seen here in 1996 at Grosmont. (Author's collection)

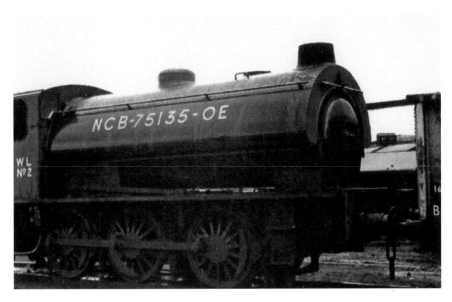

WD75135 (No. 3185). This MoS Austerity was built by Hunslet in 1944. After the war, it was sold to the Wath Main Colliery Company Ltd, and on nationalisation it became NCB (Opencast Executive) at Westfield, Lothian as WL No. 2, but was also numbered NCB 75135-OE. Both numbers were carried throughout its life. It was later transferred to NCB-OE Onllwyn and leased to contractors Derek Crouch & Sons Ltd, who operated the Maes Gwyn Open Cast site. The loco was fitted with an underfed stoker gas-producer system and four jet Kylpor blast pipe with stovepipe chimney. Unusually for a NCB loco, it is in blue livery and is here seen at Onllwyn Shed in October 1968. (H Llewelyn*)

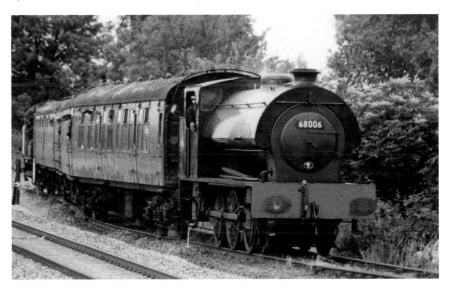

WD75141 (No. 3192) (No. 139). This is another 1944 product of Hunslet. Employed at various MoD depots, it was modified by Hunslet in 1964 for smoke emissions and used at a coking plant until withdrawn and preserved *c.* 1980. It resided at Attercliffe & Peak Rail, although it is now at Barrow Hill Roundhouse under restoration. Seen here on the Cholsey, Wallingford Railway in 1996. (Author's collection)

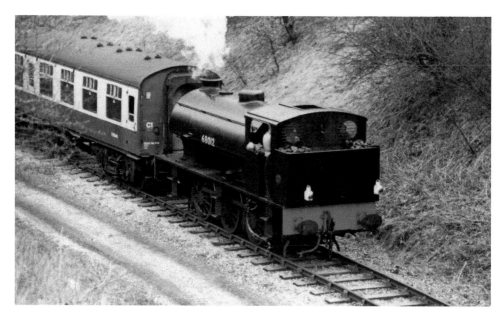

WD75142 (No. 3193) (No. 140) *Norfolk Regiment* is another Hunslet loco from 1944. It had a busy life at many MoD depots, then moving to NCB in 1962 before being rebuilt/modified for smoke emissions. It was eventually sold into preservation in 1979. It has resided at various heritage railway locations, and is currently at Bressingham Steam Museum. Seen here in 1986 at MRC. (Author's collection)

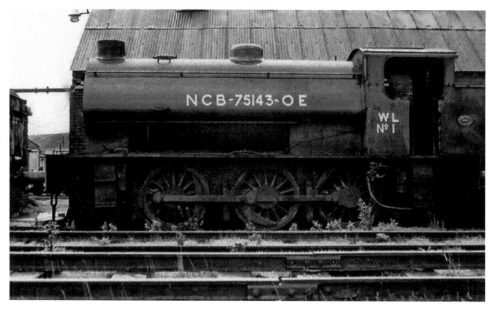

WD75143 (No. 3194). This Hunslet-built loco was supplied to the WD in 1944. Post-war it went to the NCB (Opencast Executive) at Westfield Lothian as WL No. 1, but also carried its former number. It was later transferred to NCB-OE Onllwyn and leased to contractors Derek Crouch & Sons Ltd, who operated the Maes Gwyn Open Cast site. Seen here in October 1968. (H. Llewelyn*)

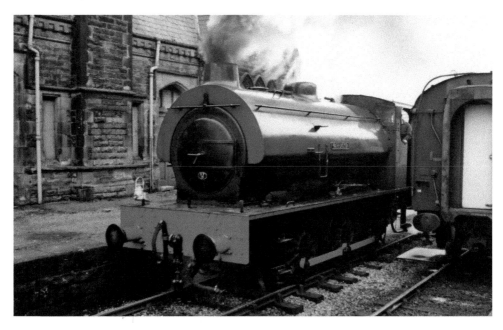

WD75186 (No. 7136) *Royal Pioneer* is a RSH-built loco from 1944, rebuilt by Hunslet in 1963 to meet smoke emissions restrictions and renumbered as HE 3892 in 1963. It was subsequently sold by Hunslet directly into preservation in 1969, moving to the Bahamas Locomotive Society at Dinting, where it then carried the name *Warrington*. When Dinting closed in 1991 it moved to Ingrow on the KWVR and thence to Peak Rail. Seen here in 1993 at Darley Dale. (Author's collection)

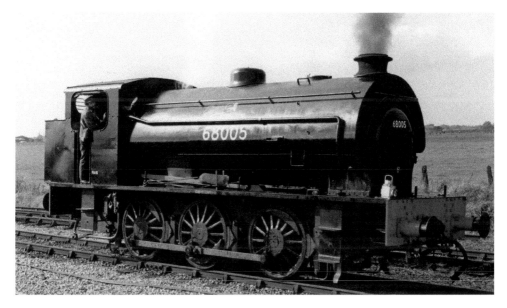

WD71515 (No. 7169). This RSH 1944-built example was sent to Ashington Coal Co. to help handle the demand for coal. It passed to NCB in 1952 and thence into preservation in 1974, where it is named *Mech Navvies Ltd* and for a time carried a spurious BR number (68005). Residing on various heritage railways, the author believes it was last with Pontypool & Blaenavon Railway. It is seen here in 1982 on the East Somerset Railway. (Author's collection)

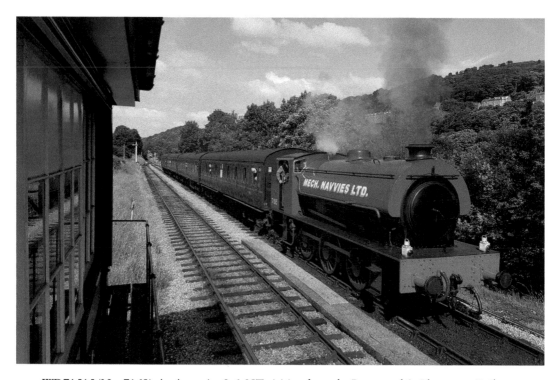

WD71515 (No. 7169). An Austerity 0-6-0ST visiting from the Pontypool & Blaenavon Railway, it waits in the loop at Damems Junction on the Keighley & Worth Valley Railway for an Up train to pass with a Keighley to Oxenhope train, 9 July 2017. It was built in 1944 by RSH for the MoD to a Hunslet Engine Company design. Initially the locomotive was sent to the Ashington Coal Company by the WD to help handle the demand for coal, but in April 1952 ownership passed to the National Coal Board Opencast Executive. In 1955 it moved to Horton Grange (Northumberland) opencast disposal point before being sent to Swalwell Disposal Point in what was then County Durham (now Tyne & Wear). At the time, the opencast disposal point was operated by Mechanical Navvies Ltd. (Richard Jones)

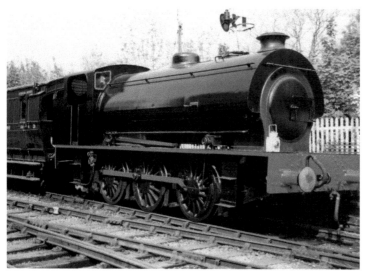

WD71516 (No. 7170) *Welsh Guardsman*. Built in 1944 and delivered to the Ministry of Fuel & Power at East Cramlington, it became an NCB loco that worked in various collieries and was a source of spares from 1976 to 1980. Into preservation it was rebuilt at the Gwili Railway using parts from other Austeritys. It is now on the SVR. Seen here in 1993. (Author's collection)

WD71521 (No. 7175). Another of the ubiquitous Austerity 0-6-0ST locos, this one named *James* and seen at Brackley Colliery on 28 March 1959. Built by Robert Stephenson & Hawthorn Locomotives in 1944 and stored at Calais, France after the Second World War. It was subsequently purchased by Walkden Collieries in June 1947. It was scrapped on-site by Wm Bush Ltd of Alfreton, Derbyshire in November 1968. (Maurice Dart/Transport Treasury)

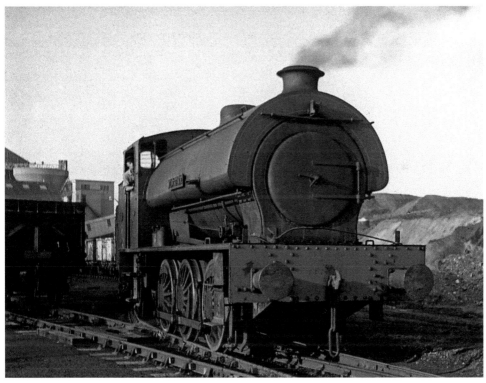

WD71526 (No. 7180) *Clock Face*. The location is Sutton Manor Colliery, St Helens, on 15 August 1966 and it is an RSH-built Austerity of 1944. Later named after one of the Lancashire collieries it worked in, carrying the name until 1967. It was sold to the NCB in May 1947 after being stored in Calais, France and was repatriated to Haydock Central Works. The loco was withdrawn from Cronton Colliery and scrapped there in September 1972 by Mee & Cocker Ltd. (Maurice Dart)

WD75158 (No. 2746) *The Duke*. Only fifty-two Austerity class were built by W. G. Bagnall & Co. and just seven survive, this one being from 1944. Like all this class, they were used in MoD depots, collieries, and power stations. This one survived into preservation in 1983 at Peak Rail, Buxton. It currently resides at the Ecclesbourne Valley Railway. Seen here in 1993 at Matlock Riverside. (Author's collection)

WD75158 (No. 2746) *The Duke*, again in 1993 – this time in company with sister loco WD75186 *Warrington* at Peak Rail. (Author's collection)

WD75178 (No. 2766) is another of the Bagnall-built examples of 1944. It was sent to France in 1945 but arrived too late for active duty and was stored at Calais until 1947, thence repatriated to UK. It worked in South Wales collieries and in September 1971 was damaged in a runaway accident. In 1977 it passed into preservation at Bristol, then Dart Valley Railway, and eventually to the B&WR, where it was restored and is an important member of the MPD. Seen here in 1982 at Buckfastleigh. (Author's collection)

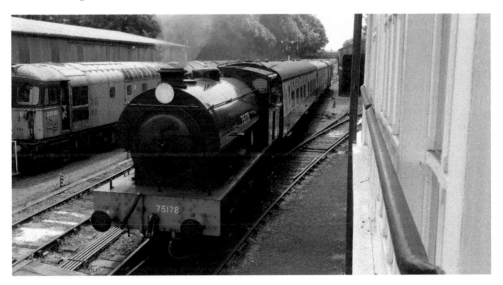

WD75178 (No. 2766). This picture shows the 1944-built W. G. Bagnall & Co. Austerity bringing in a train from Boscarne Junction on the Bodmin & Wenford Railway in Cornwall on 1 June 2019. Bagnall built fifty-two of the 377 that were built for the War Department between 1943 and 1947. This locomotive was sent to France in February 1945, but arrived too late to take any active duty in the Second World War. After two years in store at Calais it was returned to Britain and stored at Watnall Colliery in Nottinghamshire from June 1947 before being used by the NCB at various collieries until 1970. In September 1971 it was damaged when in a runaway accident, but was repaired, and in March 1978 it moved to what was then the Dart Valley Railway which is now the SDR. After a lengthy restoration undertaken by the Cornish Steam Locomotive Preservation Society, the locomotive steamed again at the B&W in October 2017. (Author)

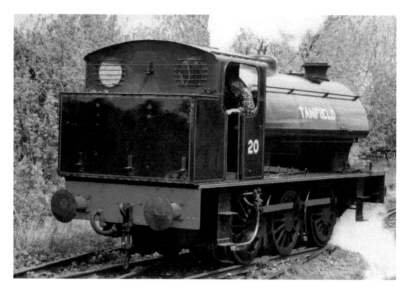

WD 75266 (No. 2779) is a 1945-built Bagnall, and like most of its classmates spent its entire life in military depots and collieries. One highlight of its career was involvement in the 1975 Stockton & Darlington 150th anniversary celebrations at Shildon, where it appeared as No. 2502/7. Now residing on the Tanfield Railway, where it is seen here in 1994. (Author's collection)

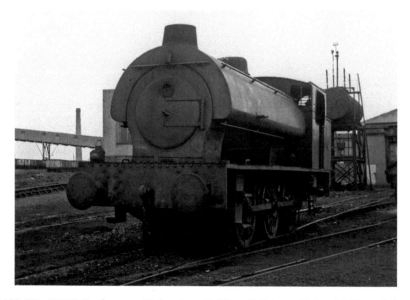

WD71480 (No. 7289) *Fred* seen at Bickershaw Colliery, Leigh on 5 May 1967. Built by Robert Stephenson & Hawthorn Newcastle in 1945 for the Ministry of Defence to a Hunslet/Riddles (LNER J94) pattern, the locomotive was delivered new to the Longmoor Military Railway (LMR) for storage in July 1945. It was deemed surplus to requirements after hostilities ended and was subsequently purchased by Manchester Collieries in November 1945, leaving the Longmoor Military Railway in April 1946. It was then used at Walkden Colliery, where it was named *Fred* after the late Fred Hilton, who at one time had been the locomotive superintendent of the Manchester Collieries railway system. Purchased by the Worth Valley Railway in 1968, it is now at Tyseley awaiting restoration. (Maurice Dart)

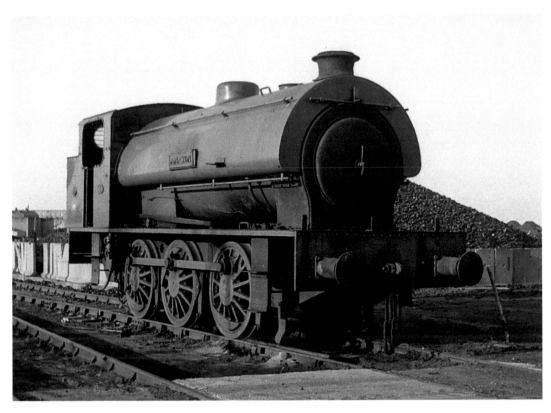

Above: WD75307 (No. 5297) *Amazon* at Sutton Manor Colliery, St Helens on 15 August 1966. Built by Vulcan Foundry in 1945, it was transferred to Harrington Colliery in Cumbria on 23 September 1967 with a subsequently unknown withdrawal date. It is not thought to survive. (Maurice Dart)

Right: WD71505 (WD118) (No. 1782) *Brussels*, an Austerity 0-6-0ST built by Hudswell Clarke in 1945, seen here with ex-LMS 8f 2-8-0 No. 8431, leaving Haworth for Oxenhope on the KWVR on 8 October 1977. (R. J. Buckley – Maurice Dart collection)

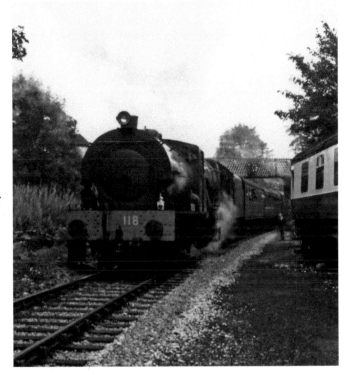

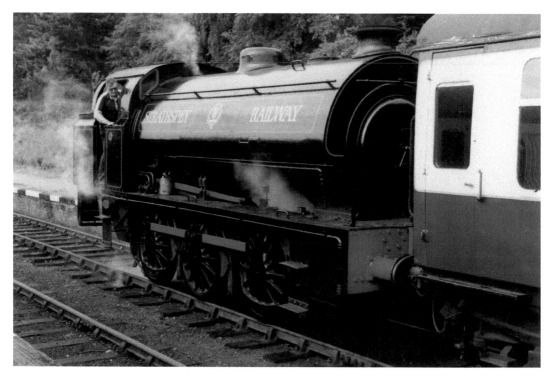

No. 3686 was supplied new in 1948 by Hunslet to the NCB No. 2 area, Durham. Modified to fit the loading gauge of the narrow-bored Lambton Tunnel at Sunderland, it worked in many collieries over the next twenty-six years, being withdrawn and stored on stand-by in 1974. Eventually it was sold to the Strathspey Railway and operated for a number of years, but is now based at Aln Valley Railway. Seen here on the Strathspey Railway in 1988. (Author's collection)

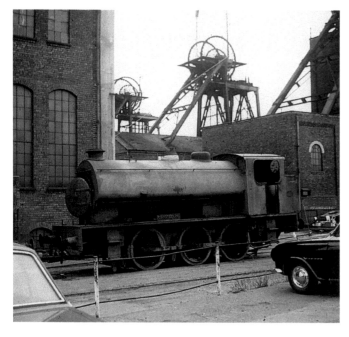

No. 3693 *Cronton*, another Austerity 0-6-0ST, seen here on 17 August 1968 at Cronton Colliery. Built by the Hunslet Engine Co. in 1950, it worked for the NCB in several Lancashire collieries but ended its career at Cronton, being scrapped on-site in June 1973. (Maurice Dart)

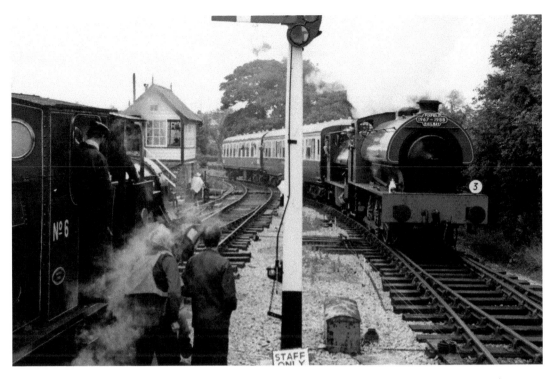

No. 3694 *Whiston* was supplied to NCB in 1950 and worked predominately in the Lancashire Coal Field until being withdrawn around twenty years later, and saved for preservation in 1983 on the Foxfield Railway. It spent a period on the Churnet Valley Railway in 2019. It is seen here at Caverswall Road, Foxfield in 1988. (Author's collection)

No. 3695 *Rodney*. Another Hunslet product, it was delivered to Walkden Central Workshops on 20 October 1950. Unlike its sister, this one has not survived and was scrapped at Bickershaw Colliery, Leigh, during w/e 3 April 1976, by Mee & Cocker Ltd. (Maurice Dart)

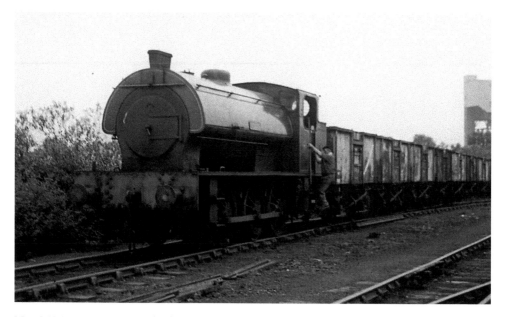

No. 3696 *Respite*, a 1950-built product of the Hunslet Engine Co. It was purchased by the
National Coal Board (NCB) and started its working life at Astley Green, Ladysmith & Bickershaw
collieries, where it worked until 1978. It was then donated to the National Railway Museum in
1982, where some parts were removed and used in the construction of the broad-gauge replica
Iron Duke. After many years stored at the NRM in York, it was reassembled and travelled by
road, becoming the first steam locomotive on-site of the Ribble Steam Railway, Preston. It is
seen here on 17 August 1966. (Maurice Dart)

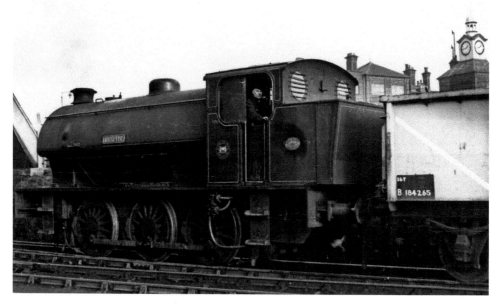

No. 3696 *Respite* shunting wagons to Walkden Exchange Sidings (L&Y) passing Walkden Shed.
Built by Hunslet in 1950 for NCB, it survives on the Ribble Steam Railway. (W. S. Darby –
A. Darby collection)

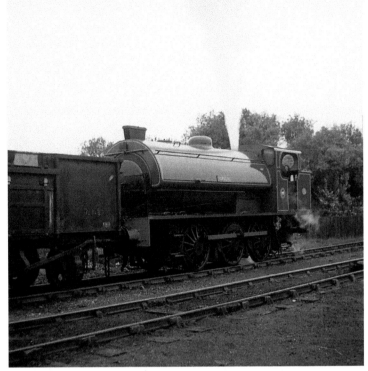

No. 3698 *Repulse*. Hunslet Engine Co. delivered this new to NCB, Walkden Railways in November 1950. It worked there until May 1973, when it was transferred to Ladysmith Washery, Cumberland, from where it was withdrawn in March 1975. The Lakeside & Haverthwaite Railway purchased it in September 1976 for preservation. Seen here on 17 August 1966 at Mosley Common Colliery. (Maurice Dart)

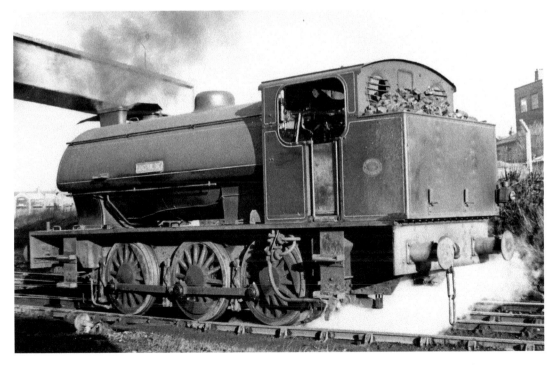

No. 3698 *Repulse*. Hunslet-built, it is seen at Walkden Shed on 21 December 1962. Built in 1950 for NCB, it survives on the L&HR. (W. A. Darby collection)

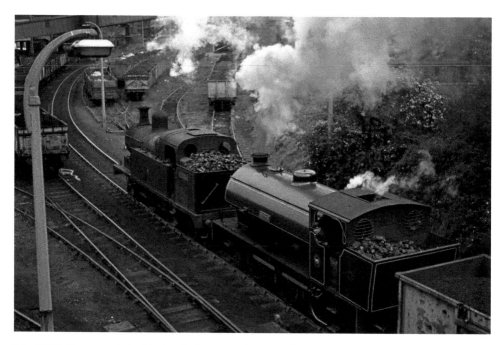

No. 3699 *Revenge*. A double-headed train with an unidentified Stoke-built 0-6-2T paired with Austerity 0-6-0ST *Harry*, seen at Astley Green Colliery *c.* 1962. The Austerity was built by Hunslet in 1950 for the NCB and was moved to Ladysmith Washery in Cumbria in February 1968. It is not thought to be in preservation. (A. Darby collection)

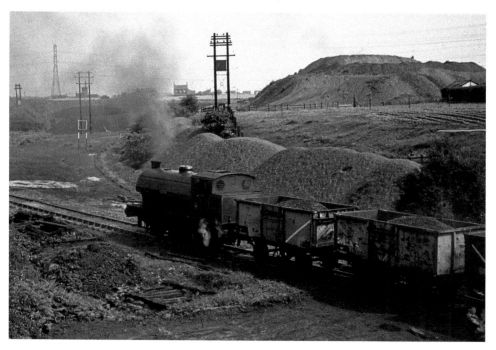

Also seen at Walkden on an unknown date is another Austerity 0-6-0ST, possibly *Revenge*. (A. Darby collection)

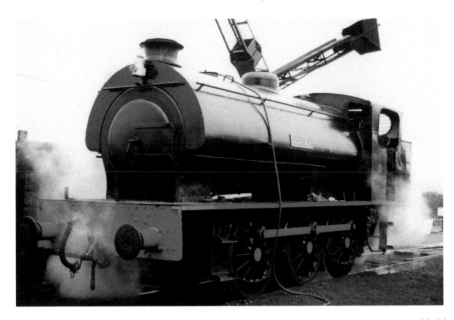

No. 3770 *Norma*. This 1950-built Hunslet worked all its life in the South Wales coalfield and in 1970 ran away down the 1-40 Dulais Valley incline. The pointsman managed to derail some of the wagons and the loco made it across the A48 road before eventually stopping. This and Bagnall No. 2758 were kept going with cannibalised spares from other locos until it was moved to Oswestry in 1980, and preserved in 1983 by the Cambrian Railway Soc. It is seen here in 1996 at Oswestry. (Author's collection)

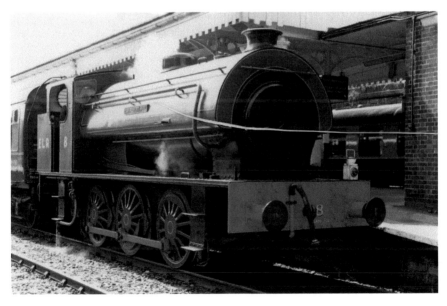

No. 3776 *Sir Robert Peel* was built in 1952 by Hunslet for NCB, and worked in several collieries until being withdrawn and entering preservation in the late 1970s. It has resided and operated at several heritage railways, and it is hoped will eventually be restored to a livery of the Walkden Colliery and renamed *Warspite* after Walkden loco No. 3778. It is believed to now reside at the E&BASR. Seen here on East Lancashire Railway at Bury in 1988. (Author's collection)

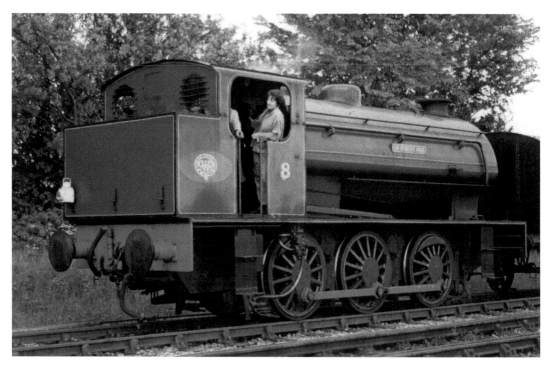

No. 3776 *Sir Robert Peel*, here at Toddington in 1995. (Author's collection)

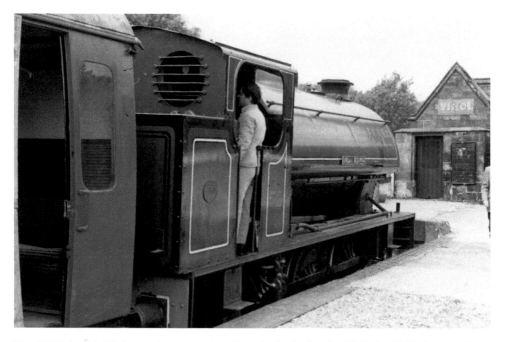

No. 3777 *Josiah Wedgwood* was another Hunslet built for the NCB in 1952. It carried the number 68030 for much of its life in preservation on the CVR (the real No. 68030 was scrapped in 1962), but resided on other railways and is now at Llangollen. Seen here at Cheddleton in 1988. (Author's collection)

Right: No. 3779 *Robin Hill*. The Austerity 0-6-0ST is seen here at Cronton Colliery, Whiston, on 17 August 1966. Built by the Hunslet Engine Co., Leeds in 1952, it was scrapped on-site by Mee & Cocker Ltd in September 1972. (Maurice Dart)

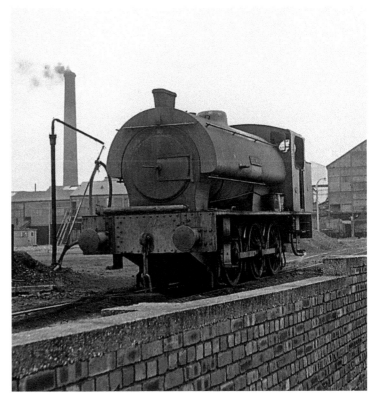

Below: No. 3781 *Linda,* seen at Maesteg Deep Shed in September 1969. Hunslet-built for the NCB, she was the last of the batch built in 1952 to the Austerity MoD design. After its NCB working life, it was purchased by the K&ESR and in 1994 was sold to the MHR and converted to side tank, becoming 0-6-0T No. 1 *Thomas*. (H. Llewelyn*)

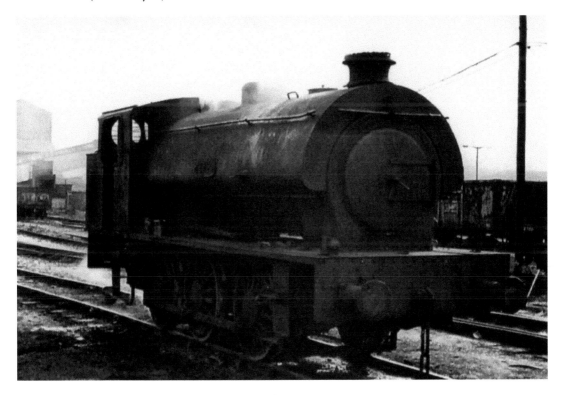

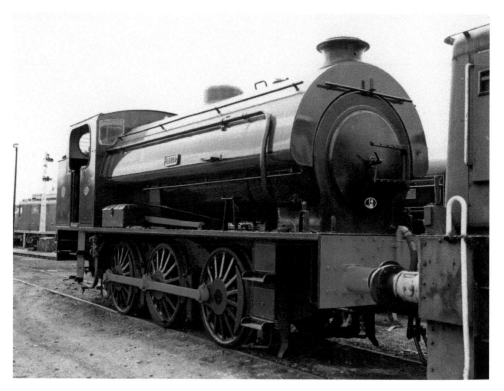

No. 3781 *Thomas* was sold by the K&ESR to the Mid Hants Railway in 1994 and converted to 0-6-0T to run as *Thomas the Tank Engine*. Seen here in 1988 at Rolvenden as *Linda*. (Author's collection)

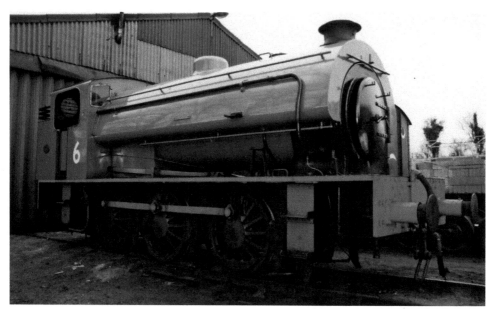

No. 3781. It is unclear why the No. 6 was applied to *Linda* while on the K&ESR line. Seen here on an unknown date. (Author's collection)

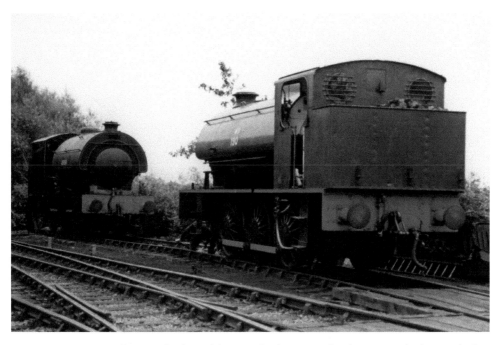

WD190 (No. 3790). This was the first of fourteen built in 1953 for the MoD, which were the last steam locos supplied to them. It was observed at Reading as part of a freight train in December 1967, when it was moved to the Royal Engineers at Shoeburyness. In 1971 the locomotive was moved to the CoVR and is currently operational. Seen here at Castle Hedingham in 1988. (Author's collection)

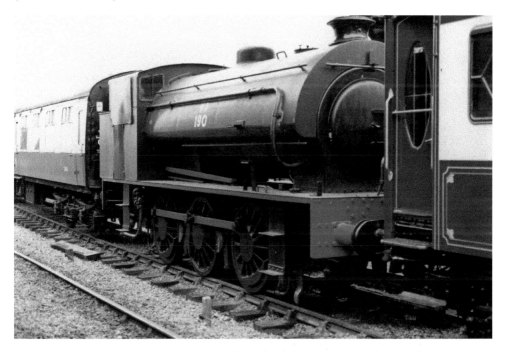

Another shot of WD190 (No. 3790) at Castle Hedingham in 1988. (Author's collection)

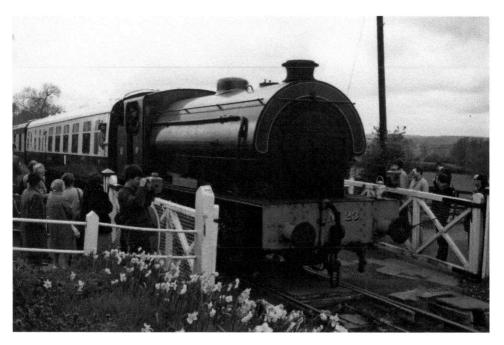

WD191 (No. 3791) *Holman F Stephens* is another of the final batch for the MoD in 1952, and after several years serving various military depots it went to the K&ESR in 1972. During its working life with the Army, it only covered 23,178 miles. Still residing on the K&ESR, it is seen here in 1983 at Tenterden. (Author's collection)

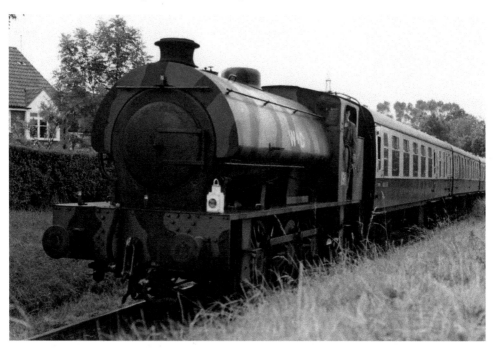

WD191 (No. 3791) *Holman F Stephens*, again at Tenterden. This shot was captured in 1988. (Author's collection)

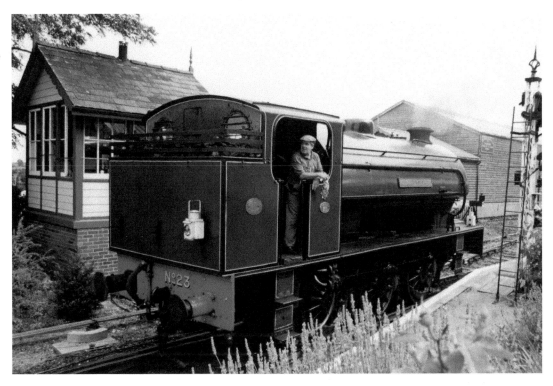

WD191 (No. 3791) *Holman F Stephens*, again at Tenterden in 1988. (Author's collection)

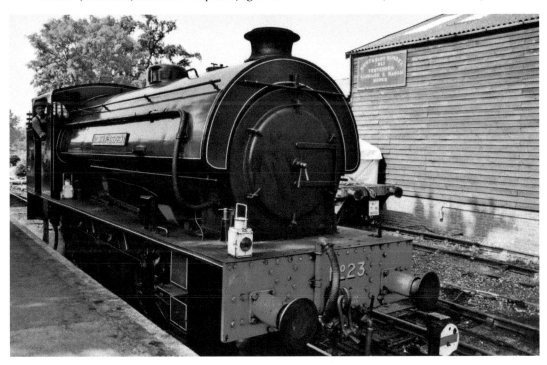

A final shot of WD191 (No. 3791) *Holman F Stephens* at Tenterden, 1983. (Author's collection)

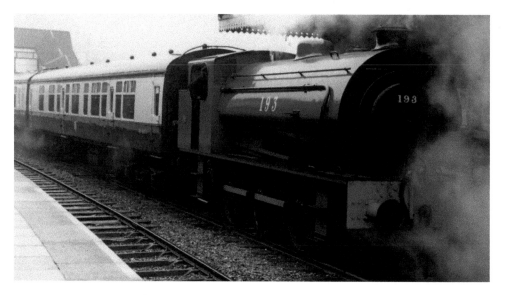

W193 (No. 3793) – another of the final MoD batch of 1953. By 1955 it was based on the Shropshire & Montgomeryshire (S&M) Light Railway at Kinnerley. In March 1960 it worked a Stephenson Locomotive Society special last train over the S & M, then through the 1960s it was kept at Long Marston (mainly in store). Purchased by the SVR in 1971, it has since resided at several heritage railways and is now at the RSR. Seen here at Llangollen in 1988. (Author's collection)

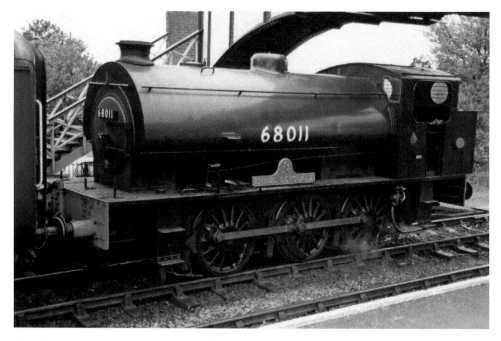

WD196 (No. 3796) No. (68011) *Errol Lonsdale* is another of the final batch built in 1953 for the MoD. During its Army life it gained stardom by appearing in the film *The Great St Trinians Train Robbery*, some of which was made at the LMR. When its military life was finished, it was sold into preservation on the MHR in 1978, and thence to the South Devon Railway, who subsequently sold it to a Belgium museum. Seen here in 1996 at SDR. (Author's collection)

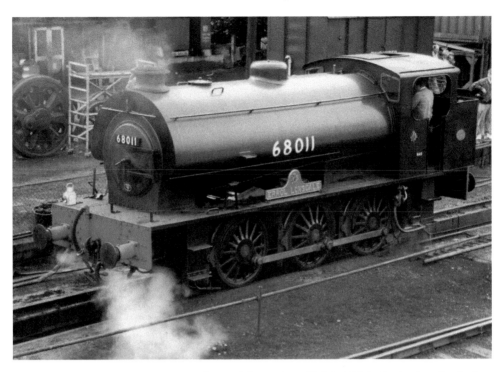

WD196 (No. 3796) (No. 68011) *Errol Lonsdale*, again at SDR in 1996. (Author's collection)

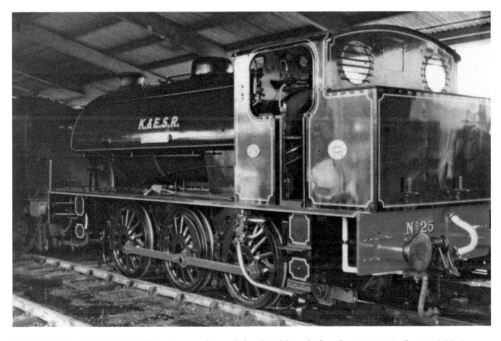

WD197 (No. 3797) *Northiam* is another of the final batch for the MoD. Built in 1953, it was preserved on the K&ESR in 1977 from Bicester Army Depot, where it had been named *Sapper*, but was still owned by the MoD until 1979. It has visited other heritage railways, but is currently back on the K&ESR. Seen here in 1982 on the Bluebell Railway. (Author's collection)

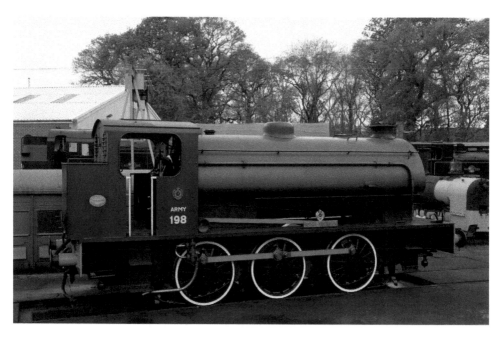

WD198 (No. 3798) *Royal Engineer*. An Austerity 0-6-0ST seen on 28 April 2019 at Isle of Wight Steam Railway. Built in 1953 for the MoD, it did not enter service until it worked at the General Stores Sub-Depot at Steventon. It then moved to Central Ordnance Depot, Bicester in 1958 and finally to HQ Engineer Resources at Long Marston in 1961. Following a long period in store it was restored and given the name *Royal Engineer* in 1971. A further overhaul followed in 1987/8 and, when withdrawn from service in 1991, it was the last operational steam locomotive owned by the Army. Now owned by the IoWSR (Author)

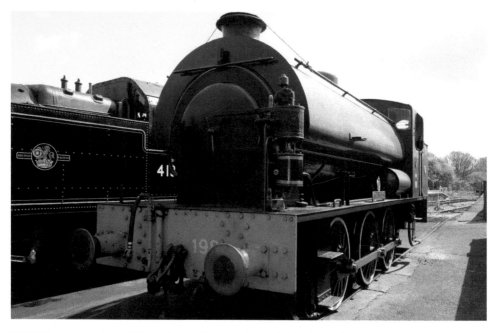

WD198, again on Isle of Wight Steam Railway in April 2019. (Author)

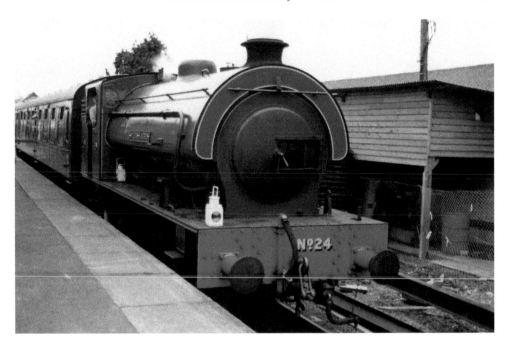

WD200 (No. 3800) (W95) *William H Austen – Rolvenden*. Privately purchased in 1971 for use on the K&ESR and numbered 24, it has since been sold and is last shown as at the CoVR. Seen here *c*. 1996 on the K&ESR. (Author's collection)

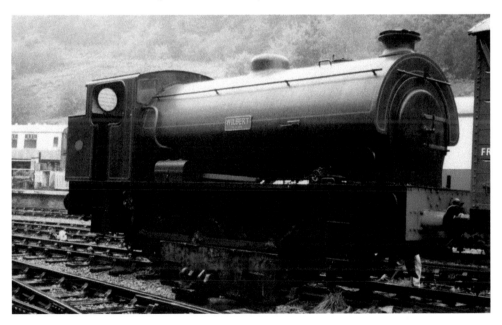

No. 3806 *G B Keeling, Wilbert – 'Rev W Awdry* was from the same batch built for the MoD, but this was for the NCB. After its colliery service it was purchased for preservation by the Dean Forest Railway in 1973 and named after the author of the Thomas the Tank Engine books, who was the president of the railway. It currently still resides at DFR. Seen here at Norchard *c*. 1995. (Author's collection)

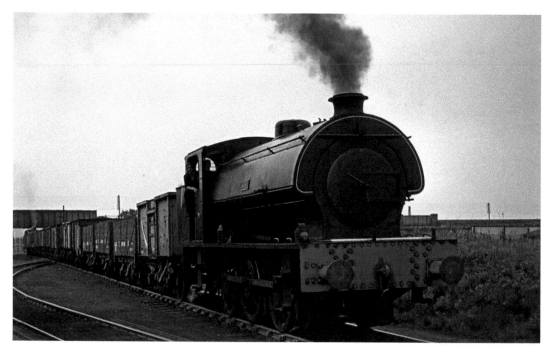

No. 3808 *Wasp*. Another Hunslet Austerity 0-6-0ST at Walkden Colliery *c.* 1964. Built in 1953/4 for the NCB, it was scrapped by Maudland Metals Ltd of Preston in March 1969. (A. Darby collection)

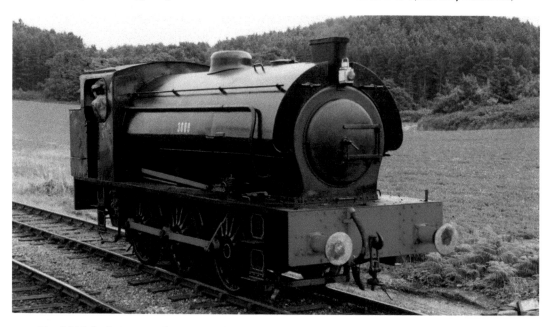

No. 3809, built in 1954 for NCB. After serving in Scottish Collieries, it was sold for scrap in 1972 to Thomas Muir Scrap Merchants in Fife and resided there for several years until it was sold into preservation in 1983. After being overhauled, it went to the North Norfolk Railway. Sold again in 2006 and again in 2008, it moved to the GCR. Here it is shown at Sheringham on NNR in 1988. (Author's collection)

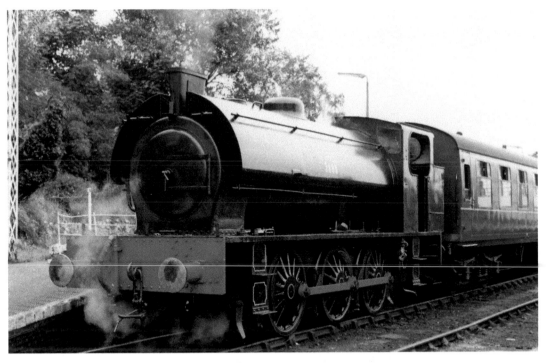

No. 3809, again at Sheringham on NNR in 1988. (Author's collection)

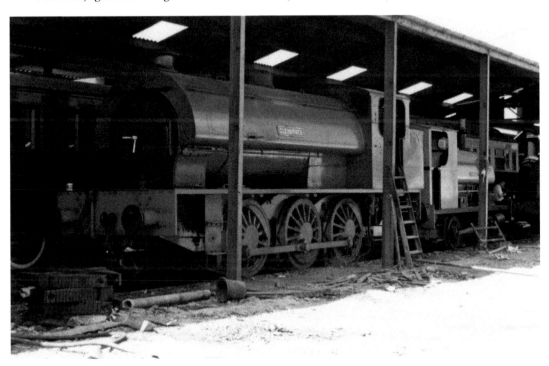

No. 3810 *Glendower* is a former NCB example built in 1954 for the South Wales collieries and now residing on the SDR at Buckfastleigh. Seen here on SDR in 1979. (Author's collection)

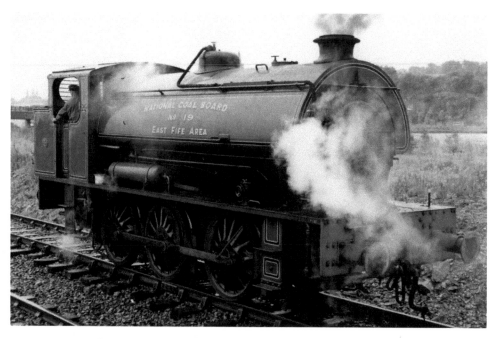

No. 3818 *East Fife Area No 19* is another of the NCB 1954 examples that, after colliery service, was purchased by the Bo'ness & Kinneil Railway and fitted with a Lempor-type exhaust, which improved its steaming. Seen here at Bo'ness in 1988. (Author's collection)

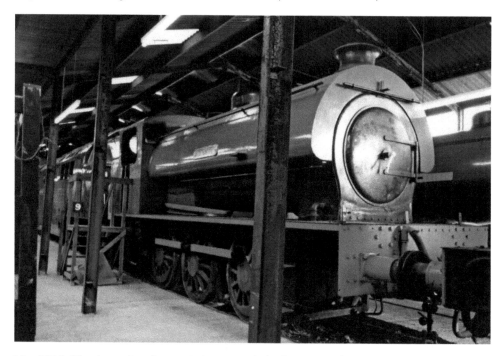

No. 3810 *Glendower* is a former NCB example built in 1954 for the South Wales collieries and now residing on the SDR at Buckfastleigh. Seen here at Buckfastleigh in 1987. (Author's collection)

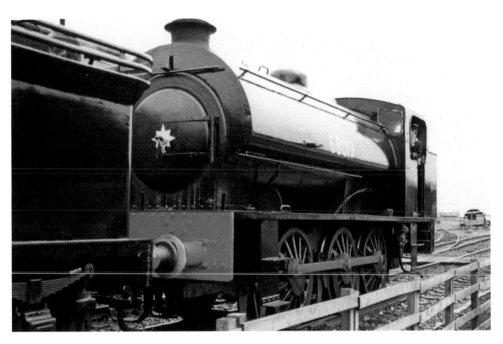

No. 3818 *East Fife Area No 19* on the B&KR when carrying the number 68019, which was originally allocated to a 1944 Bagnall example that had been scrapped by BR in 1965. (Author's collection)

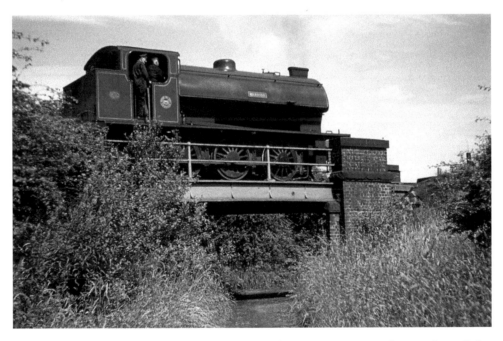

No. 3823 *Warrior*. Here we see a very smartly turned-out Austerity somewhere on the Walkden Colliery system. Built by Hunslet in 1954 for the NCB, it was transferred to Walkden Central Workshops in October 1970 and thence to Bickershaw Colliery, where is apparently was renamed *Fred*. Now on the Dean Forest Railway as *Warrior*. (A. Darby collection)

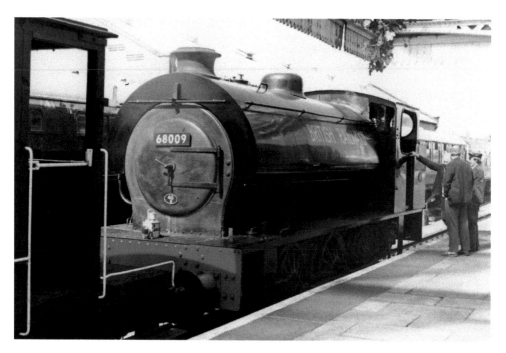

No. 3827 *No 9*. After its NCB service it moved to the GCR in 1981, where it was found the boiler and firebox were numbered 68009; this had originally belonged to a 1944 Hunslet (No. 3158) that was scrapped in 1962. It was not one of the six sold by BR to the NCB! No. 3827 has operated on a number of heritage railways and was purchased by two directors of the Stainmore Railway in 2004. Currently stored at Kirkby Stephen awaiting overhaul, it is seen in 1988 at GCR Loughborough. (Author's collection)

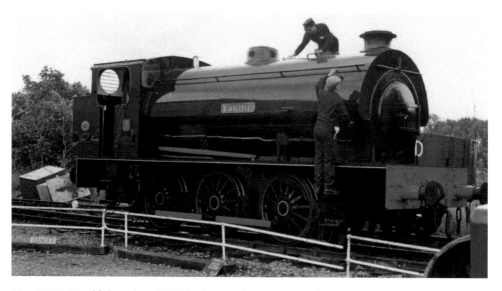

No. 3839 *Wimblebury* is a 1956-built Hunslet Austerity that spent its life in Staffordshire Collieries before being withdrawn in 1973, passing into preservation as a source of spares at the Foxfield Railway. After it was decided to restore the loco, it was fitted with vacuum brakes. Seen here on the Foxfield Railway in 1988. (Author's collection)

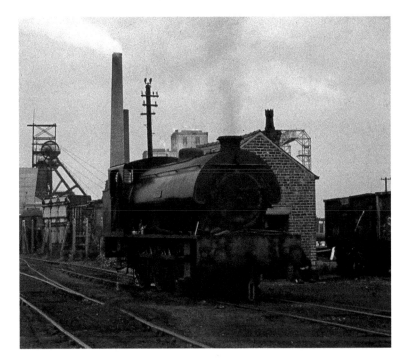

No. 3842. Austerity design 0-6-0ST was built by Hunslet in 1956 for the NCB and is seen here at Astley Green Colliery, Lancashire in 1968. It was sent for scrap to Maudland Metals of Preston in April 1969. (J. James)

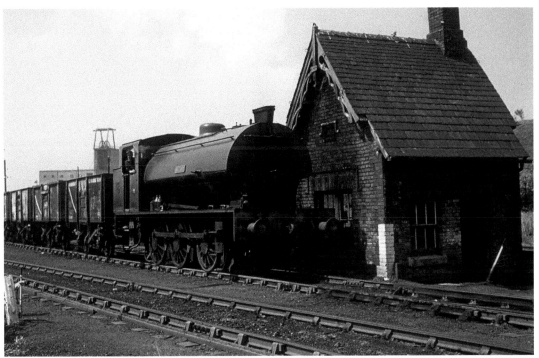

No. 3843 *Wizard*. Another of the ubiquitous Austerity 0-6-0ST, seen here on the Walkden Colliery Railway system *c.* 1964. Built for the NCB by Hunslet in 1956, it was relatively young when withdrawn and scrapped by Maudland Metals Ltd of Preston in April 1969. (A. Darby collection)

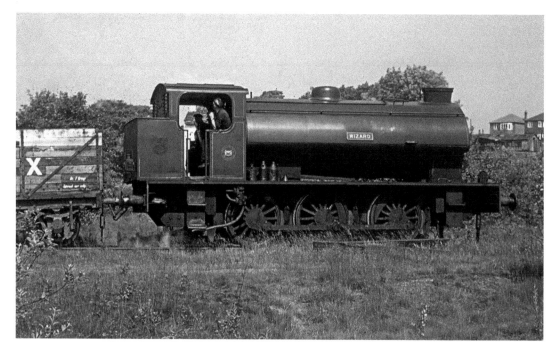

No. 3843 *Wizard* at Walkden Colliery *c.* 1962. (A. Darby collection)

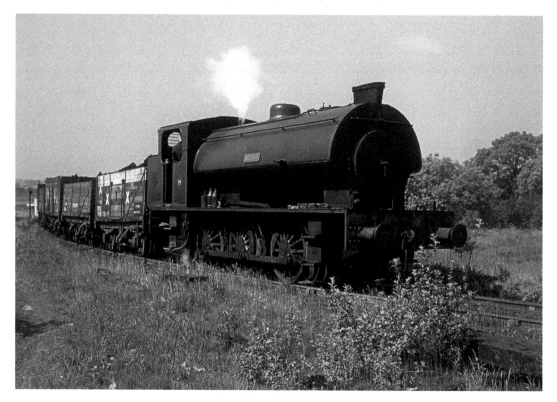

Another photograph of *Wizard* at the Walkden Colliery *c.* 1967. (A. Darby collection)

An unidentified Austerity 0-6-0ST working at Astley Green Colliery in 1968. (J. James)

Another unidentified Austerity 0-6-0ST in a very atmospheric setting, so typical of the environment these engines worked in every day. Seen here at Astley Green Colliery in 1968. (J. James)

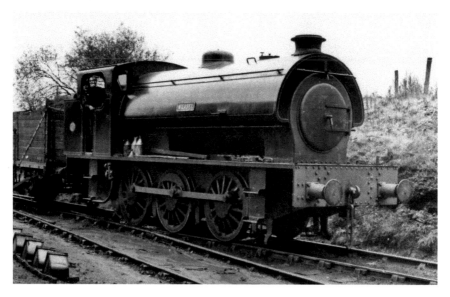

No. 3846 *Weasel*. This Walkden Railways, Brackley Colliery Austerity (J94) 0-6-0ST was built by the Hunslet Engine Co. in 1957 and served with the NCB until 1966 before being sold, becoming United Steel Co. No. 22. It was delivered new to the NCB at Graig Merthyr Colliery, but was built as works No. 3844, the identification plates being switched before it was delivered, the story being that the order for the NCB was urgent and that No. 3844 was more complete than No. 3846, and hence 3844 was delivered. It is still preserved on the Appleby Frodingham Railway in Scunthorpe. (Maurice Dart/Transport Treasury)

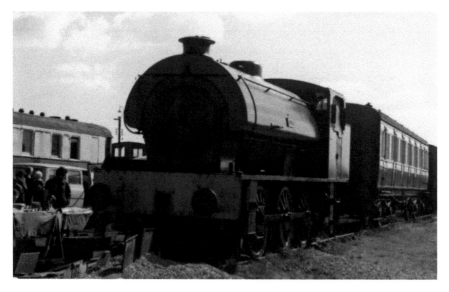

No. 3850 *Juno* was supplied new to Stewarts & Lloyds Mineral Ltd and employed in their ironstone quarries railway. Withdrawn in 1968, it was purchased by the Ivatt Trust in 1969 and moved to Buckingham Railway Centre at Quainton Road. The trust transferred ownership to the Isle of Wight Steam Railway in 2009, and in 2010 was put on loan to the National Railway Museum as the last unmodified example. It is on static display at Locomotion – Shildon. Seen here in 1977 at Quainton Road. (Author's collection)

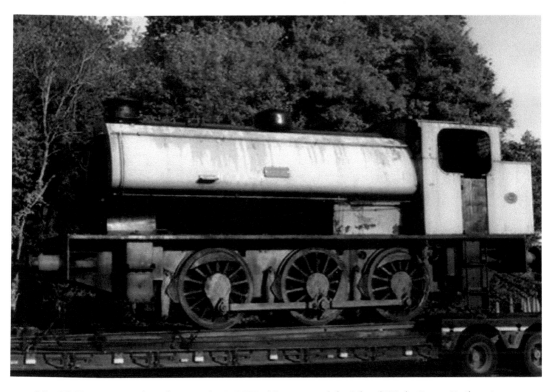

No. 3850 *Juno*, seen here leaving the IoWSR. (Courtesy of the Isle of Wight Steam Railway)

WD192 (No. 3792) *Waggoner*

WD192 (No. 3792). This interesting locomotive had a somewhat charmed life, being built in 1953 for the MoD by the Hunslet Engine Company and regarded as an Austerity. It was delivered new to the LMR in February and was placed in store. In 1955 it was working at Histon and in May 1959 was at Bicester. By May 1961 it was in store at the Royal Engineers Stores Depot, Long Marston, and in 1968 was renumbered WD92 and named *Waggoner* in recognition of its service with the Royal Corps of Transport. In April 1969 the locomotive was stored at Proof & Experimental Establishment, Shoeburyness. During 1974 the locomotive was transferred to Marchwood Military Port, Southampton, in order to work the internal passenger train service. It continued to work around the dockyard system until 1979 when its ten-yearly boiler overhaul was due.

It returned to Shoeburyness for the boiler work and a heavy overhaul, which included a repaint into LMR Oxford Blue livery with red lining. On being declared fit for use it was passed into the care of the Royal Corps of Transport Institution. Agreement was reached that the locomotive should be retained and used at Shoeburyness as a VIP train with the historic Kitchener coach, with the MoD paying for its continued use and insurance. It was seldom steamed and fortunately spent most of its time stored under cover.

The locomotive's very last task at Shoeburyness was to move the Army's only surviving railborne gun, which had been parked on a short siding for many years. This 18-inch gun had a total weight estimated at about 180 tons and it was known that at least one of the axles had seized solid. Immediately forward of the gun position the siding ran across a level crossing, which was set in concrete. Due to the soft nature of the terrain, the track under the gun had sunk by at least a foot, leaving a short, sharp climb up to the crossing. A pair of diesel locomotives had failed to budge this monster, but using a double coupling and full regulator this steam locomotive lifted the whole thing up and across the level crossing.

Another interesting fact about *Waggoner* is its starring role in 1978 in an episode of a children's television serial made by Southern Television about the Famous Five, adapted from a book by Enid Blyton. The two-part episode was called 'Five Go Off to Camp' and featured 'The Spook Train', with the railway footage featuring *Waggoner* being filmed at Marchwood with a mock-up set of a tunnel built in a siding.

In June 1984 *Waggoner* was taken to Rushmoor Arena, Aldershot for what proved to be the final Aldershot Army Show, where it was exhibited as part of the Royal Corps of Transport display. This was to be its final steaming in Army hands and after the show it was

loaded onto a Royal Engineers trailer – which had a stated maximum load capability of only 35 tons! – and was taken to the Museum of Army Transport, Beverley for permanent exhibition.

Apart from one brief spell when it was loaned for display to a theme park in the Midlands, *Waggoner* remained at Beverley. Direct responsibility for both No. 92 and No. 198 passed to the National Army Museum in 2001. In the summer of 2003, the Museum of Army Transport was unfortunately forced to close by financial problems and, following a period in store, the National Army Museum decided to place *Waggoner* on loan to the IoWSR, where it can now be seen alongside sister engine WD198 *Royal Engineer*. *Waggoner* was moved by road from Beverley to Havenstreet (the home of the IoWSR) in February 2005.

The locomotive was steamed for the first time on the IoWSR during May 2006. In May 2008 the National Army Museum transferred the ownership of both Army locomotives to the IoWSR. It is currently undergoing a significant overhaul with completion delayed by Covid-19.

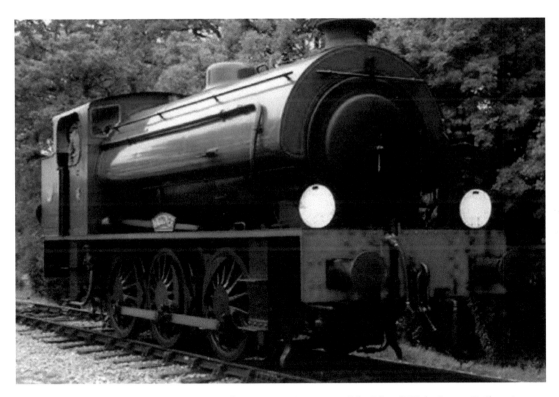

WD192 *Waggoner* and WD198 *Royal Engineer*. (Courtesy of the Isle of Wight Steam Railway)

Acknowledgements

Thanks to my wife, Julie, for her continued support whilst compiling this, my ninth book. Thanks also to Connor Stait and the team at Amberley Publishing. Thanks also to A. Darby, J. James, M. Dart, R. Jones, and H. Llewelyn for providing notes.

All photographs are credited accordingly:
Captions * – Creative Commons Attribution-ShareAlike 2.0 Generic License
Captions ** – Creative Commons Attribution-ShareAlike 3.0 Unported Generic License
Every effort has been taken to establish copyright where none is shown on original photographs, and I apologise for any photographs incorrectly credited.

Abbreviations

AFR	Appleby Frodingham Railway
B&W	Bodmin & Wenford Railway
BR	British Railways
CEGB	Central Electricity Generating Board
CVR	Churnet Valley Railway
CoVR	Colne Valley Railway
E&BASR	Embsay & Bolton Abbey Steam Railway
GCR	Great Central Railway
GWR	Great Western Railway
IoWSR	Isle of Wight Steam Railway
K&ESR	Kent & East Sussex Railway
KWVR	Keithley Worth Valley Railway
L&HR	Lakeside & Haverthwaite Railway
LMR	Longmoor Military Railway
LMS	London Midland Scottish Railway
LNER	London North Eastern Railway
LYR	Lancashire & Yorkshire Railway
MoD	Ministry of Defence
MoS	Ministry of Supply
MD&HB	Mersey Docks & Harbour Board
MHR	Mid Hants Railway
MPD	Motive Power Depot
MRC	Midland Railway Centre
NCB	National Coal Board
NSR	North Staffordshire Railway
NVR	Nene Valley Railway
NYMR	North York Moors Railway
RS&H	Robert Stephenson & Hawthorns Ltd
RSR	Ribble Steam Railway
SDR	South Devon Railway
SVR	Severn Valley Railway
WD	War Dept
WDLR	War Dept Light Railways
WSR	West Somerset Railway